HENNA

..from head to toe!

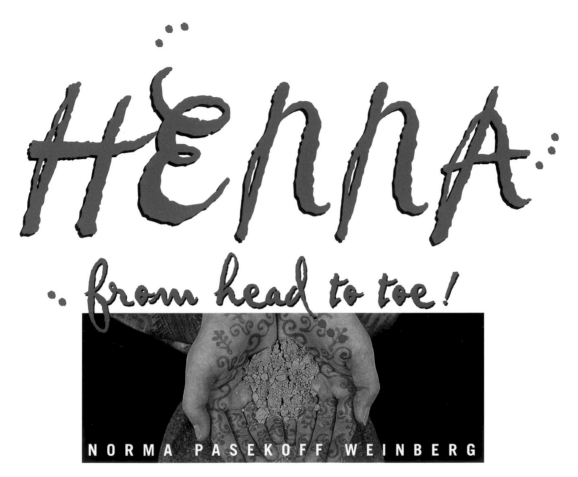

NORMA PASEKOFF WEINBERG

ILLUSTRATIONS BY CATHERINE CARTWRIGHT-JONES

STOREY
BOOKS

Schoolhouse Road
Pownal, Vermont 05261

The mission of Storey Communications is to serve our customers by publishing practical information that encourages personal independence in harmony with the environment.

Edited by Deborah Balmuth and Robin Catalano
Cover and text design by Carol Jessop, Black Trout Design
Text production by Erin Lincourt
Cover photos (upper left) Giles Prett,
(upper right and bottom) © Sacred Earth
Interior photographs by Giles Prett featuring henna designs by
Amrita Udeshi; except photo on page 5 by Dell Reich, Fruit and Spice Park
Illustrated henna patterns designed by Catherine Cartwright-Jones

Storey books are available for special premium and promotional uses and for customized editions. For further information, please call Storey's Custom Publishing Department at 1-800-793-9396.

Printed in Hong Kong by C & C Offset Printing Co., Ltd.
10 9 8 7 6 5 4 3 2 1

Library of Congress Cataloging-in-Publication Data
Weinberg, Norma Pasekoff, 1941-
 Henna from head to toe! / Norma Pasekoff Weinberg ; illustrated by
Catherine Cartwright-Jones
 p. cm.
 ISBN 1-58017-097-8 (hc : alk. paper)
 1. Body painting. 2. Body marking. 3. Henna. 4. Beauty, Personal.
I. Title.
GT2343.W45 1999
391.6—dc21
 99-10108
 CIP

Dedication

For my husband, Morris, who has been a mentor, partner, and love for half a lifetime. (He says, "For as long as I can remember!") And for my family and friends who understand and see worth in my attention to and mindfulness of the natural world.

Contents

A Decorated Life . 1

An Extraordinary Plant . 5

Coloring Hair and Conditioning Nails . 9

Henna as Natural Medicine . 17

Creating Henna Designs . 21

Preparation and Application Techniques 29

Spot and Belly-Button Designs . 37

Arm and Wrist Designs . 43

Hand Designs . 49

Foot, Leg, and Ankle Designs . 59

Chest, Back, and Neck Designs . 63

Henna Wedding Traditions . 66

Gallery of Additional Designs . 69

Recommended Reading . 72

Resources . 73

Acknowledgments

Most books list only a single author. However, any writer knows that many minds, past and present, have gathered to produce a single work. It is my pleasure to thank those wonderful people who have cooperated in the fascinating quest for the story of henna. Thanks to: my editors, Deborah Balmuth and Robin Catalano; illustrator and henna artist Catherine Cartwright-Jones; the talented staff at Storey Books; translators Rabbi Yekusiel Alperowitz, Helen Andreassian, Rachel Azaria, Jamila Bornstein, Danielle Gigot, Zeev Hadass, Sam Jabbawy, and Shyam Sunder; henna *mehndi* artists Amrita Udeshi, Anita Bhatnagar, Amen-Ra, Sheryl Baba, Reina DeBeer, Shira Freeman, Halima Abdul-Ghani, and Matty Jankowski; and those who shared their knowledge of the history and culture of henna, including Ben-Zion David, Harriet and Tony Farrish, Katrina Gannon, Jennifer Green, Kathy Kadets, Santosh Krinsky, Pamela Lappies, Dalia Magal, Vinamrata (Gitu) Mehta, Lori Pailet, Dell Reich, Georgette Salloum, Shyam Sunder, Michael Wrightson, Roy Zuckerman, Ed Murphy, Bob Slott, and the reference librarians at Harvard's Botanical, Fine Arts, and Medical Libraries.

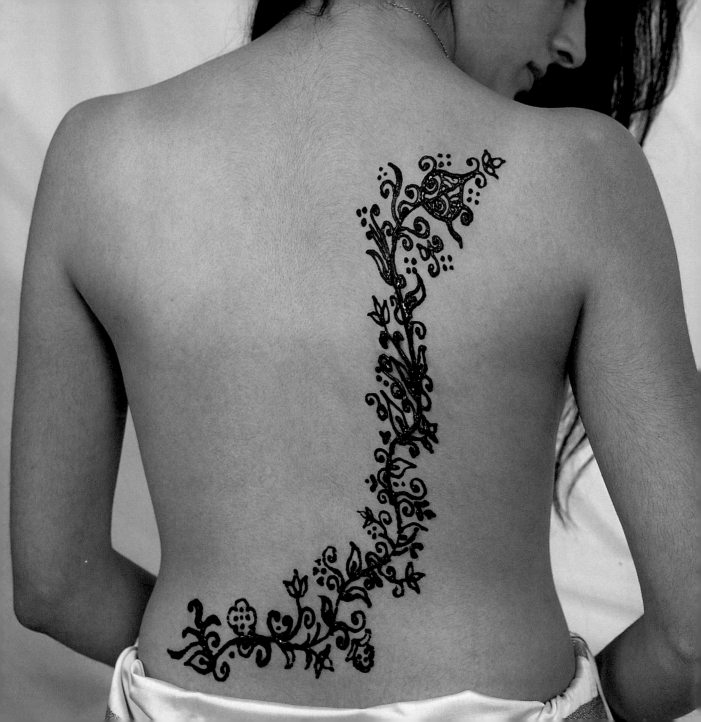

A DECORATED LIFE

Cosmetics, hair color, jewelry, perfume, tattoos, costumes . . . is it human instinct to adorn the body? Do we have a biological summons to create a certain allure about ourselves?

We are a species that arrives "naked," save skin and hair — no scales, feathers, or fur. Perhaps we feel drab surrounded by the birds, the bees, the flowers, and the boundless colors of nature. To some extent, our trimmings must serve us as a second layer, a secure boundary over our vulnerable skin.

The Origins of Body Adornment

Since the beginning of life on earth, we humans have been intrigued with body decoration. In the time before recorded history, at least 100,000 years ago, early human cave dwellers braided seashells into their hair and wore bone necklaces. Later, Stone Age civilizations painted their bodies with plant and mineral dyes to suggest group membership and rank. Symbolic body coloring became a magical part of hunting rituals, religious festivals, and ceremonies.

Matty Jankowski of The New York Body Archive observes that by transforming our bare skin into a canvas of symbols and marks, we express social, cultural, or religious attitudes. Body ornaments offer us a way to create identity, rites of passage, group belonging, status, authority, and even sexual interest. The patterns may have changed, but bedecking the body is still a strong indicator of our values and self-image.

◁ Henna designs are both a meaningful and beautiful form of body decoration.

Early Uses of Henna

The practice of henna body decoration predates Islam. Henna is thought to have first come into use in Egypt for coloring fingertips and fingernails, palms of hands, and soles of feet. One of the earliest documented uses of henna is found in the archaeological evidence of Egyptian tombs in the Valley of the Nile. Mummies of Egyptian rulers and their families were prepared to enter the next world with henna-tinted fingernails. Hieroglyphs named henna as *pouquer*.

The Egyptian government has replanted henna shrubs, called Egyptian Privet, in the gardens of the Temple of Amun at Karnak to symbolize henna's historic uses by Ramses I of the 19th dynasty, 1320 B.C.

What's in a Name?

Henna has had such a wide sphere of influence that its name is spoken in many tongues.

LANGUAGE	NAME
Arabic	*henna, al khanna*
Bengal	*mehedi*
Berber	*lhenni*
Egyptian	*pouquer*
Farsi	*hina*
Greek	*kinna*
Hebrew	*kafer, kopher*
Hindi	*mehndi, mehadi, mehari*
Javanese	*pachar kuku*
Latin	*camphire*
Sanskrit	*mehandika, sakaohera*
Sumatran	*inai parasi*
Thai	*tien kao*
Turkish	*kina*
West Indian	*mignonette tree*
Yemenite	*shazab*

THE MANY USES OF HENNA

Henna, a truly "giving tree," has played a role in the traditions of civilization, health, and body adornment for over 5,000 years.

Henna is recognized as a dye plant, a cosmetic, a medicine, and a measure of protection from evil influences. Customarily applied for ceremonial occasions and celebrations, it is placed on the parts of the body most associated with external sensory contact — the hair, the hands, and the feet.

A POWERFUL PLANT

Folk wisdom says that henna strengthens the bonds of the relationships between generations. Applying henna body art designs involves touch. Most often this close contact is given by the henna artist to the recipient, and usually by one woman to another. The henna artist is seen as a confidante and a shaman who chooses designs relative to the region, the local art and culture, and the temperament and characteristics of the person receiving the pattern.

What Is Henna?

Henna *(HIN-uh)* is the Persian name for this hedgelike, bushy tree that has been cultivated for millennia mainly for its opposing, smooth, lance-shaped leaves. When these leaves are dried, crushed, and made into a paste, they yield a natural orange to brown-red temporary color or stain. Henna dyes are primarily produced in North Africa (Morocco, the Sudan, and Egypt), Southwest Asia, India, and Pakistan.

A member of the loosestrife family (Lythraceae), henna is native to Arabia, Egypt, Morocco, Mauritania, Mali, Senegal, Sudan, Iran,

Pakistan, Madagascar, and Australia. It is naturalized in northwestern India, Nepal, and tropical America — where it is planted and also thrives in the wild.

The Indian Mehndi Tradition

Henna's first roots in India are in question. During the reign of Augustus, Emperor of Rome (27 B.C.–A.D. 14), Egypt became an important trade center for commerce between Rome and India. There are ancient murals in the Ajanta-Ellora caves near Mumbai (old Bombay) dated before A.D. 350 that, remarkably, show a princess of Pataliputra reclining under a tree, half asleep, having her hands and feet painted with flowery henna designs. Historians mention that henna may have been brought to India along with Persian horses around A.D. 712. What is known is that henna has been cultivated in Rajasthan since around 1476.

BODY PAINTING AS FOLK ART

The use of *mehndi* or henna became a significant part of Indian folk art soon after the advent of the Muslims. The orange-red *mehndi* color was often painted on new brides. The women were painted with intricate designs in order to distinguish them from unmarried young virgins, who were in danger of being kidnapped by the Muslims. From that time onward, it is said that *mehndi* flourished as a decorative art in India.

Hindus consider *mehndi* as very dear to Lakshmi, goddess of wealth and fortune. If ever there was a plant associated with luck and prosperity, it is the henna bush.

A Celebrated Fragrance

For centuries, the enticing perfume fragrance distilled from the petals of henna flowers has been praised in poetry and great books. Some have compared the volatile oil of henna flowers to the fragrance of the rarest Otto Tea Rose. This perfume is still used in northern India and Java.

The flower scent known as *camphire* in biblical times was presumed to be the source of Cleopatra's perfume, *cyprinum,* in which she dipped the sails of her barge before her seductive meeting with Antony. In the Bible (Song of Songs 1:14 and 4:13, approximately 250 B.C.), you will find this comparison: "My beloved is unto me as a cluster of camphire [henna blossoms] in the vineyards of En-gedi."

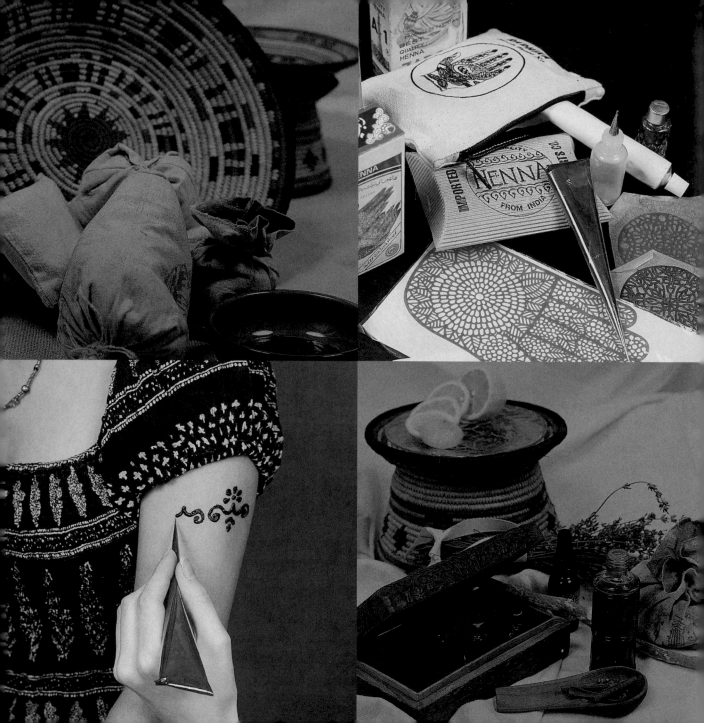

An Extraordinary Plant

Henna is like a person's life.
You work hard to achieve enlightenment.
With henna, the best color is available only after
it has been on the grinding stone.

— Urdu verse

The praises of this versatile plant are sung in the folk sayings of many languages. It is one of the only plants that is considered a symbol of love, eternal youthfulness, prosperity, and long life.

Growing and Processing

There are at least four botanical varieties of henna. As a crop, henna grows best in sun and in heavy, water-retentive soils. It reaches heights from 6 to 25 feet (1.8–7.6 m). The plant has large clusters of small — ¼-inch (6 mm) or less — very fragrant white, rose-colored, or cinnabar-red flowers with pea-size, blue-black fruit capsules. The fruits contain small, triangular seeds.

The shrub takes three years to mature, after which it undergoes pruning. It is then harvested twice a year, fall and spring, when the

◁ **Clockwise from top left:** Bulk bags of fine henna powder; stencils, applicators, powders, and oils typically found in a henna kit; herbs, oils, fruits, and spices used to create color effects; a henna artist applying a design.

△ The henna bush in full bloom.

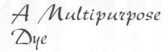

A Multipurpose Dye

Besides adding tint to people's hair, fingernails, and skin, henna dyes have colored the hooves, manes, and tails of white horses and "branded" the bodies of camels, donkeys, and cattle.

Henna has been employed extensively for dyeing fabrics such as silk and wool, staining leather and other skins, and tinting baskets, bags, and mats.

green leaves are gathered and placed in the shade to dry before market. Some henna plantations have been in existence for 100 years. Termites are the major enemy of this crop.

The leaves can be used fresh when pounded on a flat slab with limes, alkanet roots, green okras, or fenugreek seeds. It is believed that the finer the henna leaves are ground, the redder the color they will yield.

Checking for Quality

Color, purity, and fineness determine the grades or qualities of henna powder. When you buy henna, remember that the substance marketed for hair color is often less refined and may have added ingredients. Henna for body decoration is generally more filtered and pure.

The most expensive henna is finely ground (like talcum powder), with few leaf or twig fragments; it is fresh, nearly dustless, pure, and soft green. It gives the brightest color.

PURCHASING HENNA POWDER

Because henna is a plant product, there will be variations from one batch to another, and one country to another. For safety, be sure to read the ingredients label. Buy only pure, unadulterated, natural henna. Do *not* buy henna products that contain black hair dye. These are risky for use on the skin and have not been approved by the U.S. Food and Drug Administration.

The choicest henna leaves for body art reportedly come from the top of the henna bush. The richer the green, the fresher the herb. Old henna will have oxidized, look brownish, be dusty, and unusable. Good henna powder will have a distinct smell.

Common Questions about Henna

Is henna a natural product?

Yes. Henna is a natural pigment, and in most people will cause no harm. The leaves are cut from the plant, dried, and ground into a powder. Some commercial henna products may have added ingredients; always read the labels. It is best to do a patch test to be sure that your skin is not sensitive to this plant. For directions, see page 23.

Does it hurt to apply henna to the skin?

No! Whether for everyday wear or special celebrations, painting henna on the skin is a painless beauty treatment. It is a pleasant and relaxing experience. The most difficult part of getting a henna design is sitting still for the time required, which can be anywhere from 30 minutes to several hours depending on the complexity of the design.

What does henna smell like?

Some people love the smell of henna and others cannot tolerate it. Henna paste has a distinctive scent similar to a barnyard or to damp clay. Still, the odor has been described by some as an aphrodisiac!

How is a henna decoration different than a tattoo?

Both tattoos and henna body decorations are ancient arts. Permanent tattoos are applied by tattoo artists using a needle that pierces the skin; the process can be painful. Henna designs are applied with a pastry-bag-like cone or a toothpick-type instrument that does not pierce the skin; henna feels great going on.

Tattooing is illegal in some cities and states. The inks or dyes used for tattoos are color additives, and the U.S. Food and Drug Administration (FDA) has not approved these color additives for use on the skin. Unsterile tattooing equipment and needles can transmit infectious disease, and you cannot donate blood for one year after getting a tattoo. Henna decoration is a plant dye that is beneficial for most skin types. It heals skin irritations and can act as a sunscreen.

Tattoos are not easily removed and, in some cases, may cause permanent discoloration. Henna body designs will fade naturally in 2 to 3 weeks, depending on the original color of the henna, how long it is left to dry, your skin type, the number of soap-and-water washings, and any exfoliation of the area.

What are the usual colors of henna decorations?

Depending on your body chemistry and skin color, the designs can appear as orange, red, brown, burgundy, or khaki green. The color of henna also is based on the strength of the dye-paste mixture, and the length of time it is left in place.

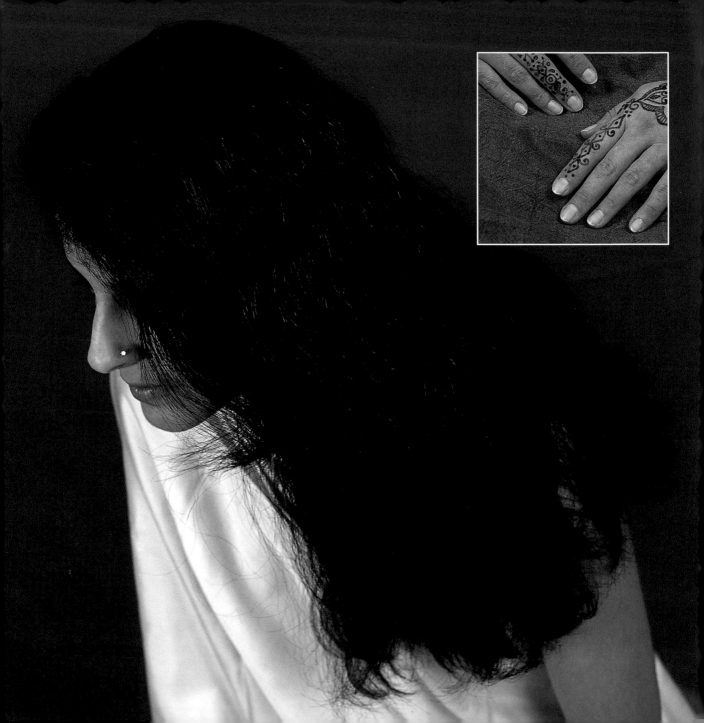

COLORING HAIR AND CONDITIONING NAILS

*D*o you love to experiment with recipes? Are you comfortable with new experiences? Consider the at-home adventure of highlighting and conditioning your hair with henna. Used for centuries, henna is a safe, vegetable colorant that generates few allergic responses.

How Henna Works

Henna, a natural, botanical, semipermanent colorant, enhances brunette and redhead hair tones. By coating and smoothing the outer cuticle layer of each strand, henna not only protects the hair from sun, surf, and air pollution, but also creates a surface that reflects light. Henna will never make a brunette into a blond because there are no harsh chemicals to strip away the hair's natural color.

Tony Farrish, president of Rainbow Research Henna, says that hair is made darker and richer by leaving the henna on longer.

THE MANY BENEFITS

In addition to adding highlights to dark hair and darkening the color of lighter hair, henna adds elasticity and body. By holding split ends together, henna increases hair shine.

◁ While regular henna can be used to tint hair, the neutral powder is an excellent conditioner for both hair and nails (inset).

Beauty Secrets of the Past

Two of the most famous, intelligent, and beautiful Egyptian queens used henna to enhance the natural luster of their hair and nails and illuminate their sex appeal. Nefertiti (1366–1349 B.C.), whose name translates to "the beautiful one comes," is remembered as a redheaded enchantress who formed an alliance with the 18th-dynasty pharaoh, Akhenaton. Cleopatra VII (69–30 B.C.), the most famous of all the Cleopatras (there were several Egyptian queens by that name), was a cosmetics pioneer and a proponent of henna. Roman generals Caesar and Mark Antony adored Cleopatra for her allure, as well as her wise political strategies.

Using Henna on Gray Hair

Santosh Krinsky, president of Lotus Brands Light Mountain Natural Henna, soundly recommends previewing your desired henna color by doing a strand test before you begin the process. Permed, gray, and treated hair all tend to be drier and more porous than untreated locks. When the henna has fully developed, the effect may be a more intense tint than you expected.

Do not use pure henna on hair that is all white unless you are going to a costume party. The outcome could be clownlike — tresses of orange or pink. Experiment with *neutral* henna, which adds body and shine.

Some say that applying henna to the roots of the hair is naturally cooling and helps relieve tension around the eyes and forehead. Perhaps tinting the beard or mustache with henna also eases tension in the jaw. Using henna has the added benefit of conditioning the scalp and relieving dandruff buildup.

Normal wear and tear on the hair — shampooing, brushing, swimming in a chlorinated pool — will cause henna to fade, sometimes unevenly. However, henna will never show tell-tale demarcation lines.

WHEN NOT TO USE HENNA

Since henna leaves are considered body cooling and astringent, folk wisdom advises against henna hair coloring when the air temperature is very cold, when you are sick, or when you are pregnant.

Getting Started

Before coloring your hair with henna, you'll need to gather a few supplies. In addition, be sure to allow yourself enough time to complete the entire process; 2 to 24 hours are required, depending on the depth of color you are trying to achieve.

Keep in mind that henna will take to distinct hair types (such as Asian hair, African hair, or mustache and beard hair) and various hair colors in particular ways. The condition of your hair may also differ from time to time. Understand that each batch of natural henna will differ in intensity and brightness.

Henna hair coloring will last 2 to 3 months. Don't panic if at first the shade seems too brash or even too dull; it will probably vary in the first 3 days. It is the nature of this extraordinary plant.

Simple Facts about Hair

The thin outer layer, or *cuticle*, of the hair, has 5 to 10 overlapping *keratin* scales arranged in a fashion similar to fish scales. Under the cuticle layer lies the *cortex.* This is a dense, tubular layer of keratin that provides strength and holds the granules of *melanin* or pigment. Heredity determines the color and diameter of our hair, and time and health factors may alter that initial recipe. A well-balanced diet and exercise are necessary to maintaining healthy locks.

Doing Patch and Strand Tests

Any substance, natural or artificial, can cause an allergic reaction. To be safe, request a trial sample of the henna you plan to use. Read the contents list and try a patch test *24 hours prior to each use.*

Rebecca James Gadberry, a professor of cosmetic sciences at the University of California at Los Angeles, recommends these steps:

1. Place a bit of henna paste, the size of a small plastic teaspoon, just below your ear. Cover it with gauze and let sit overnight. If your skin becomes red, burns, itches, or shows any other sign of irritation, do not use this brand of henna.

2. Cut off a 1" x 1" (25 mm x 25 mm) section of hair and dip it in the henna paste; or coat a small section of hair and wrap this in plastic wrap. Leave on for the recommended time. This procedure will give you a preview of what this shade will look like on your hair. This step is extremely important, because the resulting hair color is difficult to change. Also, be aware that chlorine residue from swimming pools can react with the henna, altering the color. To protect your tresses, wet your hair and apply a tablespoon of conditioner before putting on your swim cap.

Dos and Don'ts

Do store henna in a cool, dry, dark place.

Do test your hair's elasticity before applying henna. Pull off a single strand of hair, wrap around index fingers, and stretch. If the strand does not increase by a minimum of one-third, the hair will need pre-conditioning.

Do check commercial henna hair products for pesticides and heavy-metal testing.

Don't use henna in the area of the eye, your eyebrows, or internally.

Don't use henna on newly chemically treated hair; it may cause unplanned color variations.

Don't coat the hair with henna right before getting a perm. Henna can inhibit the activity of the perm chemicals, and thus, alter the perm's results.

Don't use black henna that contains para-phenylenediamine chemicals, which can cause serious inflammation of the skin.

Caution

To apply henna hair color, you will need only the henna powder and several simple-to-gather items that you probably already have around the house. *Never* use metal bowls or utensils for mixing; they can react with the natural chemicals in the henna.

Basic Henna Recipe

The powdered leaves of henna are applied as a thick paste to clean and dry or towel-dried hair. If the henna is too watery, it will drip and stain your face and neck. If it is too dry, however, it will form tiny balls that fall everywhere; reserve extra warm water to add as the paste dries.

For those with coarse, curly, or gray hair, a second application or "double process" of henna may be necessary. Use plain henna paste first; rinse the hair after five minutes. Then reapply the henna (plus any add-ins you desire), wait at least an hour, and rinse again. Here's a handy gauge of the quantity of henna you will need:

> Henna powder (army green color): 2–3 ounces (60–90 g) for short, fine hair; 3–5 ounces (90–150 g) for medium-length hair; 5–8 ounces (150–240 g) for long hair
>
> Boiled spring- or distilled water, cooled to a warm temperature

1. In a bowl, mix the henna powder with enough warm water to form the consistency of chocolate pudding.

2. To avoid tinting the skin around your hairline, clip back the hair and apply cream or oil around the perimeter of your face; include the tops of your ears and back of your neck. You can also place a thin roll of cotton over this cream to soak up any extra henna paste. If you drip henna on your skin, try washing with a bit of shampoo or lemon juice as soon as possible.

3. Put on an old tee shirt and disposable rubber or plastic gloves. Place paper towels on the counter. Section your hair into 1-inch (25 mm) parts. Using a brush or your fingers, apply henna paste to the roots of your hair. After all are covered, work the henna paste down the hair shaft.

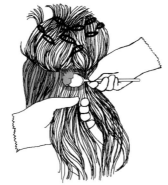

4. Cover your hair with a shower cap and top with an old towel or scarf. Allow the henna to saturate your hair for anywhere from 2 to 24 hours (depending on the intensity of the color you want). Because henna is activated by heat, you can shorten the process by using an electric hair dryer for at least 30 minutes at a comfortable setting. Or, try sitting in the sun for 30 minutes!

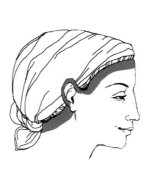

5. After the allotted time, rinse the henna paste from your hair until the water runs clear. If possible, do not immediately use shampoo. Let the hair dry naturally.

6. Later in the same day, shampoo with an acidic-pH shampoo. Towel-dry, then massage a small amount of coconut oil into your hair. Cover your hair with an old shower cap and leave the oil on for at least 1 hour, then rinse.

Supplies

- Oil or cream (such as jojoba extract, olive oil, shea butter, or petroleum jelly)
- Your oldest tee shirt, towel, and scarf
- Roll of strip cotton, paper towels, old newspaper
- Plastic hair clips
- Henna hair-coloring powder
- Boiled spring- or distilled water
- Glass, ceramic, or plastic bowl
- Wooden or plastic spoon
- Several rubber or plastic disposable gloves
- 1½" (40 mm) paintbrush or tinting brush (optional; can use fingers)
- Plastic shower cap
- Electric hair dryer (optional)
- Coconut oil
- pH-balanced shampoo and conditioner

Neutral Henna

This form of henna is extracted from immature leaves and stems of the leaves and branches of the henna plant. Neutral henna can be used on any color hair to increase shine and volume and reduce oiliness. You can create various hair-color highlights by diluting neutral henna with hot water and accenting the paste with herbal add-ins.

Neutral henna is applied for only 15 to 20 minutes. It is difficult to obtain a perfectly neutral or colorless product; try different labels until you find the right one for you. According to Michael Wrightson of Logona Vegetable Hair Colors, a neutral henna process can be repeated every 6 weeks. (See suggested add-ins on opposite page.)

Tips from around the World

To vary your henna hair color, stir some of these color enhancers into the henna paste mixture:

Allspice, cinnamon, or nutmeg. If the smell of henna is not exactly to your liking, add ¼ teaspoon (about 1 g) allspice, cinnamon, or nutmeg to the paste.

Apple cider vinegar or lemon juice. Add 3 tablespoons (45 ml) vinegar or fresh lemon juice for golden or copper highlights. This treatment also is beneficial for oily hair.

Egg yolk or whole egg. An egg yolk or a whole egg will help condition and add shine to the hair. Use the yolk for dry hair, and the whole egg for oily hair.

Cloves. Cloves deepen and enhance the color of henna. Grind ½ teaspoon (3 g) dry whole cloves to a powder and add to the henna paste.

Cognac. Add 1 tablespoon (15 ml) cognac and 1 tablespoon (15 ml) olive oil to effect a redder henna color.

Tea. To set the henna color, steep a full-bodied tea for 20 to 30 minutes. Substitute the tea liquid for the required water in the paste. Black China or Ceylon tea adds golden highlights to brown hair.

Coffee. To tone down the reds and deepen the browns, use brewed — not instant — coffee as a substitute for the water in the paste. Brew at least 1 cup (260 ml), bring to a boil, and then let the coffee sit as long as possible (overnight is preferable) before adding to the henna mixture.

Olive oil. The addition of 2 to 4 tablespoons (30–60 ml) of olive oil conditions and moisturizes hair. This is particularly good for dry, brittle hair.

Henna Nail Care

Improve the plight of dry or splitting fingernails or toenails by conditioning them with neutral, uncolored henna once or twice a week. Henna paste has both antiseptic and antifungal properties and also can be applied to inflamed or irritated skin around the nails.

Nail-Conditioning Treatment

Here's an easy, low-cost routine. Remove existing nail polish a day or two before treatment. Remember to stir the paste each time.

- ½ cup (130 ml) boiled spring- or distilled water, cooled to warm
- ½ teaspoon (2.5 g) uncolored, neutral henna powder
- 1 teaspoon (5 ml) plain organic yogurt (optional)
- 2–3 drops eucalyptus oil (optional)

1. In a plastic or glass bowl, mix neutral henna and water to form a paste. Store leftover mixture in a sealed container in refrigerator for 2 to 3 days only.

2. Using a chopstick or flat-edged toothpick, glob the henna paste on each of your clean, dry nails and cuticles. Keep paste on for 10 minutes. If you have time, put both hands in a plastic bag and cover with a towel for as long as possible.

3. Rinse your fingers in lukewarm water and towel-dry. Gently buff the nails with a chamois nail buffer. Then coat your nails with deep, penetrating avocado, almond, or calendula oil.

Neutral Henna Add-Ins

For blondes, steep fresh or dried chamomile flowers in boiling water, and use this liquid as a replacement for the water.

For strawberry blondes, try pot marigold (calendula) flower or rose petal tea added to neutral henna. (Use organic flowers.)

For redheads, hibiscus flower tea, cranberry juice, or beet juice offers interesting shade variations. Substitute for the water in your mixture.

For light brunettes, mix one sweet potato (baked, skinned, mashed) with ½ cup (130 ml) strong coffee or tea. Add this mixture to the neutral henna.

For dark brunettes, brew ½ cup (130 ml) coffee or strong tea and add to neutral henna.

For black hair, ½ cup (130 ml) grape juice mixed into neutral henna gives an interesting bluish black hue.

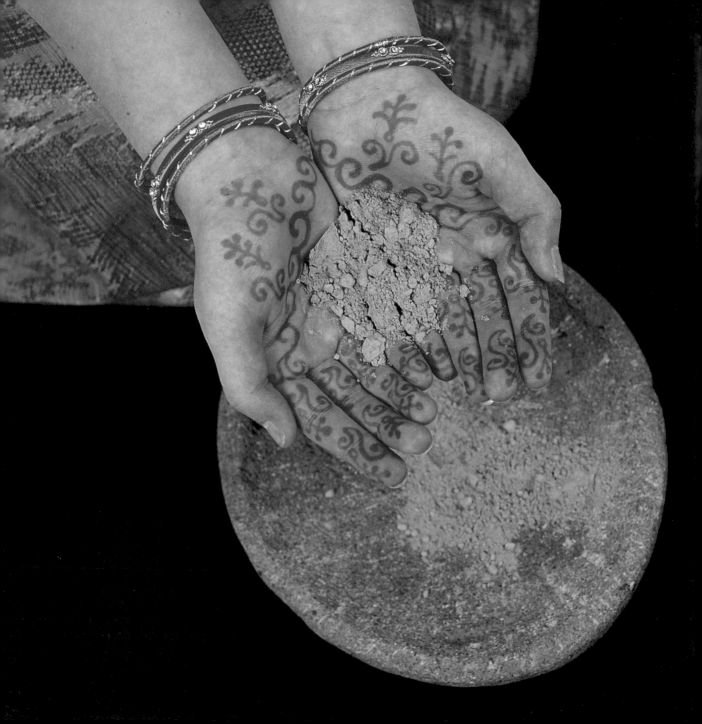

HENNA AS NATURAL MEDICINE

*Henna makes pure and good the hand's acts,
and eases the path followed by the feet.*

— from *Tales of the 1,001 Nights*

Henna is an ancient herb of grace and healing. It is mentioned as a valuable medicine in Egyptian hieroglyphs, in Solomon's Song of Songs of the Old Testament, and in the writings of Theophrastes, a disciple of Aristotle who wrote the *History of Plants*. Mohammed advised his followers to use henna as the tint of Islam and the herb of Eden; he applied henna to his wounds. Agastya, a Hindu sage of medicine and science, wrote in the 12,000-verse *Agastijamamouni*, a sacred book of India, a reference to henna as the "guardian of the pulse" and the enemy of diseases.

How Henna Works

When applied to the skin, the active elements in a paste of henna leaves provide a cooling and astringent action along with protection against many surface fungi and bacteria. Henna can help to lower body temperature to soothe headaches, fevers, burning feet (which may be a B-vitamin deficiency), and even hysteria or a violent temper.

BOTANICAL NAME:
 Lawsonia inermis, L. alba;
 Family Lythraceae,
 Loosestrife
PARTS USED:
 Leaves, bark, flowers
ACTIVE PRINCIPLES:
 Coumarins, flavonoids,
 napthaquinones, sterols,
 tannins
PROPERTIES:
 Antiseptic, astringent,
 antibacterial, antifungal,
 antispasmodic (relaxing),
 antipyretic (cooling), topical
 sunscreen, and sunburn
 soother
MEDICINAL ORIGINS:
 Medicinal use of henna is
 part of Ayurvedic and Unani
 Indian folk medicine and
 North African healing
 traditions.

◁ Powder from the henna plant has the ability to cool, soothe, disinfect, and relax.

A Natural Coolant

To reduce a child's fever, a ball of henna paste is placed in the palms of the young person's hands. Residents of Mali, West Africa, who are exposed to daily temperatures over 100°F (above 38°C), coat the soles of their feet with henna to cool and protect them against the searing earth. Also, Bedouins in the United Arab Emirates henna-dye the bottom of their feet in the summer to insulate the body from the heat of the sand and prevent symptoms of heat exhaustion such as headaches and soreness of the eyes.

In India, Arabia, and Africa henna formulas have been applied to seal wounds, soothe mild burns and insect stings, fight nail fungus and the fungal infections of athlete's feet, heal acne, dry sores, and toughen skin against abrasion. Natural pearl fishers in Kuwait and the Persian Gulf paint henna paste on their palms to reduce chafing and sweaty hands and thus, prevent blisters from rowing or hauling.

In Malaysia, a decoction of the herb's leaves makes a gargle for sore throat and hoarseness, and a filtered tea relieves diarrhea and dysentery. In India, Nepal, and Java the local peoples apply a cooled liquid infusion of chopped henna leaves and clove oil on herpes blisters. Alcoholic extracts of the henna plant do show mild anti-microbial properties against salmonella, *E. coli*, and several oral infectious diseases.

Headache Remedy

In addition to the relaxing and cooling properties of the henna seeds, anise seeds are also a good antispasmodic.

1 tablespoon (15 g) henna seeds, outer shells cracked and inner seeds ground
1 tablespoon (15 g) black anise *(Pimpinella anisum)* seeds, crushed
Boiled, cooled water or apple cider vinegar
1 gauze compress

1. Using a mortar and pestle, pound and grind together the henna and black anise seeds. Add just enough water or vinegar to make a paste.

2. Spread the paste onto a gauze compress. Apply the compress to the head, lay down to rest for 15 to 30 minutes.

Irritated Skin Balm

Lawsome may be the ingredient in henna that serves as an antiseptic, bactericide, and fungicide. This remedy will not stain the skin.

 2–3 tablespoons (10–15 g) neutral, uncolored henna powder
 4–5 ounces (130 ml) apple cider vinegar, warmed

1. Mix henna powder with warm vinegar to form a paste.

2. Apply as a dressing directly to the affected area of skin.

Scalp Treatment

Try this updated Indian and Pakistani remedy to increase hair growth and reduce hair loss.

 1 tablespoon (15 ml) henna flower oil
 1 tablespoon (15 ml) jojoba extract
 1 tablespoon (15 ml) calendula infused oil
 ½ teaspoon (2.5 ml) carrot seed oil
 2 drops essential oil of clove bud
 4 drops essential oil of rosemary
 5 drops East Indian essential oil of patchouli
 2 drops essential oil of cedarwood

1. In a 2- to 3-ounce (60–95 ml) opaque bottle, combine henna, jojoba, calendula, and carrot seed oils. Add essential oils and shake to mix. Label and date.

2. If desired, warm the bottle of oil in a warm-water bath before using. Massage a few drops into scalp before bedtime. Apply two or three times a week.

Multipurpose Plant

Old herbals advised the use of henna as a deodorant. In the early 20th century, Nubians carried henna leaves under their arms as deodorizers. In Algeria, henna leaves, worn in sandals, protected against "evil-smelling" feet. In Nigeria, the essential oils of henna flowers are rubbed on the skin to reduce perspiration and perfume the body.

In Yemen, those of a venerable age still wash their bodies with rose water then color their hands and feet with a henna paste to preserve a smooth and supple skin. Arab medicine advises inhaling the scent of henna's fresh flowers as a cure for sterility or loss of passion!

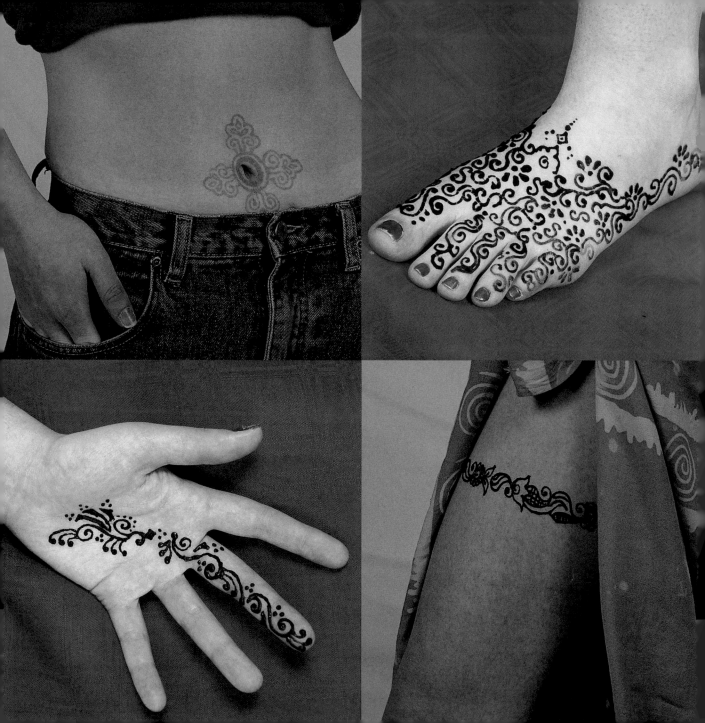

CREATING HENNA DESIGNS

*H*enna body art designs are usually inspired by the imagination and creativity of the artist. You too can be a henna designer! Designs can be left- or right-handed, simple or complex. All you need is a steady hand, a great deal of patience, and a creative spirit.

The application of henna body art is an enjoyable, relaxing ritual that is just right to perform with family members or friends. Learn and practice henna painting with a partner; it is usually easier to draw the designs on someone else than on yourself.

Invite your friends for a "henna hen party," T.G.I.F. celebration, a sweet-16 birthday party, an engagement gala, or any other occasion of your choosing. Include in your evening henna paste, lots of laughs, relaxing Asian music, and, perhaps, the delicate fragrance of an exotic incense. Complete the night with everyone attempting the art of belly dancing. It will be memorable!

Regional Henna Designs

Organic henna body art designs vary by country or region, within the cultural boundaries of beauty and tradition. Shapes, patterns, and application techniques often are particular to a given area.

Designs of the Past

In the 1850s, women of Persia used henna to dye their hair and stain their bodies with figures of trees, birds, animals, stars, suns, and moons. Patterns were drawn from the chest to the navel. Men dyed their beards, nails, hands, and feet. In the same period, Egyptian women stained the soles of their feet, palms of their hands, and nails in a striped fashion.

Henna is praised in this Arabic adage: "Hinna, lil Far'ah wil Sa'adah wil Ha' lawah wil Jamal, ha'tah tah'futh'nah." ("We use henna to celebrate, to be happy, to be beautiful, to protect us.")

◁ **Clockwise from top left:** A finished belly-button design, with the paste scraped off; an intricate foot design using a scroll motif; a band of blossoms and paisleys painted around the thigh; an Arabian-inspired palm decoration.

North African

Indian

Arabian

Contemporary

NORTH AFRICAN STYLE

The Berbers, people of the mountainous and desert regions of North Africa, incorporate bold geometric patterns with intricate dots and wavy lines into their henna designs. These decorations are a reflection of how the artists view their landscape, coupled with their religious beliefs. The patterns are easy to see from a distance.

A North African henna artist is called a *negassah.* Berber tools for applying henna can be as simple as a finely pointed twig. African patterns can also be intricate when applied in stencil fashion. Thin strips of adhesive tape are placed on the feet to create diamonds, squares, triangles, or lengths of evenly spaced perforated circles.

INDIAN STYLE

Mehndi patterns of India and Pakistan correspond to the birds and tropical plants of their regions. Ornate, arabesque designs may consist of delicate paisleys, lace-like tracery, peacocks, mangoes, leaves, hearts, and faces.

Application tools are most often either a small, flexible plastic cone, a flat-edged toothpick, or a squeeze bottle with a fine tip. Many *mehndi* artists *(mehndi walles)* find that the henna cone offers a great deal of flexibility for intricate designs.

ARABIAN STYLE

The peoples of the Arabian peninsula esteem decorations that incorporate vines, scrolls, and flowers. As in the North African tradition, followers of the Islamic religion usually do not paint representational art of animals or people.

Tools for Arabian henna art might be a *mishwak* (twiglike stick), toothpick, or kohl stick (eye makeup applicator).

CONTEMPORARY DESIGNS

Today the marvels of henna body art have catapulted around the globe. Designs are no longer confined to local indigenous decorations, customs, and beliefs but include a melange of impressions that marry the past with the present.

Application tools include plastic cones, toothpicks, marking pens, Jacquard bottles, color transfers, stencils, and more.

Getting Started

Are you ready for the henna challenge? These simple exercises will get you going on the right hand or foot (pun intended).

DRAWING PRACTICE

You'll only need a paper and pencil to begin experimenting with various shapes and designs. If you are practicing while in the kitchen, you could use a small squeeze bottle of mustard on a paper towel or a small tube of gel icing and a large toothpick. Keep a notebook handy, and when you have time, practice basic forms to improve your freehand drawing and design capabilities.

Do *not* hold the drawing tool the way you are accustomed to writing; when you progress to henna designs with a toothpick or a paste-filled cone, you will need to hold these utensils differently. Now is the time to practice holding these implements in the most comfortable manner for henna designs:

❧ Hold the pencil or marker as you would hold a lightbulb you were threading.

❧ Hold the pencil as if you were moving a computer mouse.

Patch Test

If you have sensitive skin, perform a small patch test before applying any major henna designs. There have been very few contact dermatitis reactions to pure henna or henna dust, but every person reacts differently. It would be rather nasty to henna the bottoms of your feet and then find that you were allergic to this bush!

Apply a small amount of the henna paste to your inner arm. Let it dry, then gently dab with a solution of lemon or lime juice and sugar. Wait 30 minutes, apply eucalyptus or olive oil, and then scrape off the paste with the dull edge of a butter knife or an old credit card. Wait 24 hours before going forward with your henna project.

To begin basic design practice:

1. On paper, start drawing straight lines first on a vertical plane and then on a horizontal plane. This is the stage where repetition will build skill. Can you get your lines really straight? It is easier to practice on a flat paper surface. Remember, it will be a bit more challenging on skin.

2. Draw two parallel horizontal lines and fill them in with zigzags and dots.

3. Draw perfect circles. These will become flowers and leaves. Try sketching circles within circles, or circles outside of circles.

4. Draw triangles. Use three separate strokes.

5. Draw squares. Are the lines of equal length?

6. Draw diamond shapes (two triangles meeting at the base).

7. Draw waves or curls, both right-side up and upside down.

8. Draw large, lazy Ss. Then angle the Ss. When you are comfortable with the Ss, add dots, circles, or leaves. These Ss will become vines and paisleys that you can incorporate into any design, whether it is for an armband, anklet, bracelet, or ring.

9. Draw oblong or oval shapes: long flower pods, teardrops or raindrops, and hearts.

10. Now combine any two elements. For instance, draw a square inside a circle or triangle. Or try a cross inside a circle, zigzags inside two parallel lines, lines or circles bisecting lazy Ss, or even dots or leaf shapes at the points of a diamond.

11. Can you combine three elements? Save these ideas in your notebook for future reference.

Color Intensity

Henna designs will be the brightest on the palms of your hands and soles of your feet, where the skin is coarser and there is less pigment and body hair. These areas also are more porous and generally warmer than other parts of your body. Henna color is enhanced by body heat.

Henna designs also act as sunscreens. Body designs can create unusual tanning patterns.

If you want to rehearse what it's like to have a henna temporary tattoo, you might try a faux henna paper transfer that will only last a couple of days. Or begin with a safe temporary body paint or marker. (See Resources for more information.)

BEGINNER'S PROJECTS

It may be helpful to begin the henna experience with one of these more forgiving media. The easiest body surfaces on which to practice the art of henna or *mehndi* are the palm of your hand and the inside of your forearm, above the bend of the wrist.

Practice your design with a pencil on paper, and progress to a fine-tip, washable marker on paper. Then graduate to a 4-inch (10 cm) tube of prepared cake frosting gel. Or put some ready-made chocolate pudding in a quart-size or smaller ziplock bag, and snip open a pin-size hole in a bottom corner of the bag. Begin to draw on a paper towel to adjust the flow and control the steadiness of your hand. Prepare now for drawing sweet things on a hand or arm. It's very agreeable to lick off your mistakes! Finally, reach for the real thing — a flat-edged toothpick and a small bowl of henna paste, and later, a pre-mixed henna tube on paper, on a peeled banana, and then onto skin.

Designs for Different Hand Types

Look at the contour of your palm. Do you have a wide, strong palm or a long, narrow, artistic hand? Here are some guidelines in creating henna hand patterns with energies that complement you.

EARTH HAND

A wide, square palm with short fingers symbolizes an Earth Hand. Perhaps this is the hand of a farmer, a gardener, or a bricklayer. A henna design for this hand might be bold and enclosed within a square to accentuate strength. Patterns that distinguish the Earth personality are symmetrical and based on circles and squares.

AIR HAND

A square palm with long fingers is an Air Hand, the hand of a quiet and patient intellectual. This person could be a mathematician, an editor, a banker, or an accountant. Henna patterns that balance the Air Hand are diamond shapes, harmonious and orderly patterns.

FIRE HAND

A long palm and short fingers describe a Fire Hand. The Fire personality is independent, enthusiastic, intuitive, emotional, and sometimes rebellious. Patterns that suit the Fire Hand are triangles and diagonals, or are asymmetrical.

WATER HAND

The Water Hand has a long palm and long fingers. A Water personality may be receptive and adaptable, but outwardly sensitive and shy. Henna patterns that flatter this type of hand are curves, ovals, and spirals with flowery, soft patterns.

DESIGNS FOR DIFFERENT FINGER AND SKIN TYPES

Finger designs on the palm side of the hand can include vines decorated with leaves, dots, semicircles, teardrops, and other small shapes. Or perhaps you favor geometric patterns: zigzags, triangles, squares, and the like. The length and shape of your fingers and your imagination will be your guides. Begin henna application with your middle finger. Start at the lowest knuckle and work up to the tip.

If your skin is naturally dark, you may find that bold designs with areas of relief or space around them are more striking than using many clustered motifs. If your skin is very fair, you might prefer delicate floral designs that weave along languorous vines and leaves.

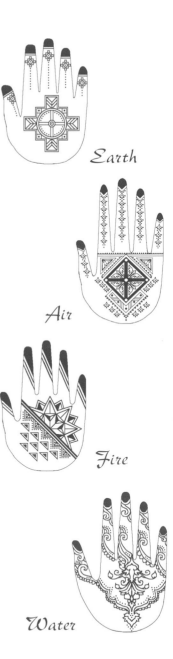

Earth

Air

Fire

Water

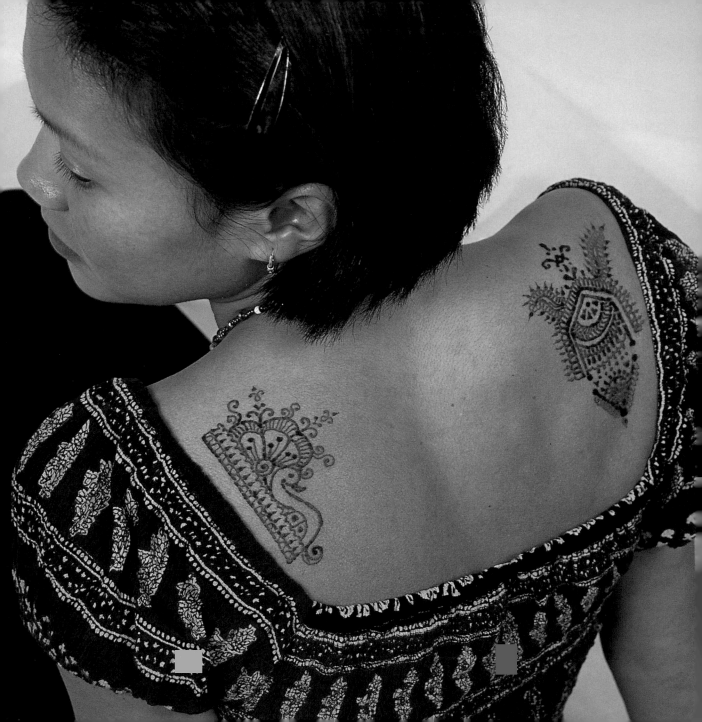

PREPARATION AND APPLICATION TECHNIQUES

Before applying designs, you must prepare both the henna and your skin. Also, you should become familiar with different application techniques, and use the one that works best for you.

Don't be afraid to buy henna in bulk rather than in a prepared kit. It's less expensive and offers more value. However, look for henna that is marketed specifically for *mehndi*, or body art, *not* hair dye. It will be of a finer grade with fewer twigs and leaf fragments, saving you sifting time.

Making the Paste

The goal is to have a toothpastelike or hot cream of wheat consistency that allows the henna paste to be extruded from the tip of a cone in a fine string. If you are using a toothpick applicator, the henna texture can be a bit thicker. You can store henna paste, covered, at room temperature for up to 3 days.

There are as many recipes for henna paste as there are henna aficionados. Here are two to get you started.

◁ These stunning designs were applied with the traditional henna cone.

Sifting

Henna used on the skin should be almost the consistency of baby powder or flour, and free of extraneous twigs or pebbles. If you can, prepare the henna the day before use; the color will be richer.

Stretch a nylon stocking or the tightest weave silk or nylon scarf over a container and secure it with a rubber band. Place an old cloth under the bowl. Place 1 to 2 teaspoons (5–10 g) of henna powder on top of the stocking, and with your index finger or the flat edge of a plastic spoon, push the henna back and forth until it enters the bowl. Sift up to three times, if necessary.

Skin Preparation

Henna works best on clean, grease-free, nonhairy skin. For at least a day before application, try not to apply moisturizer, sunscreen, or other cream to the part of the skin that will be decorated. If you want to put body art in a hairy skin spot, consider shaving or using a depilatory the day before painting a design.

Before applying henna paste, scrub the skin with soap and water and pat dry. Some henna artists like to pat the skin area with a small amount of eucalyptus oil before beginning the henna design, but be sure the recipient is not sensitive to eucalyptus before using.

Basic Henna Recipe

Eucalyptus oil, which is antiseptic and helps open the skin's pores, is readily available at most pharmacies.

- 1 teaspoon (5 g) powdered henna, sifted to a talcum powder consistency
- 2 teaspoons (10 ml) distilled water or brewed dark tea, boiled and cooled to room temperature
- 5 drops eucalyptus oil
- 2 drops clove oil

1. In a glass or plastic bowl, combine the henna powder, water, and eucalyptus oil. Mix only after all the ingredients have been added, and mix only in one direction (clockwise or counterclockwise). Stir quickly to eliminate all lumps.

2. If possible, let the paste ferment for at least 5 hours before using. Cover the mixture but do not seal or refrigerate. To test consistency, gather paste on a spoon and invert. The paste should drop off the spoon in 10–15 seconds.

The Tap Dancing Lizard's "No Fail" Henna Recipe

- 2 heaping tablespoons (30-plus g) pure henna powder, sifted twice
- Juice of 2 lemons or limes, strained to remove pulp
- Brewed coffee or tea

1. Add the juice to the henna powder, a little at a time, stirring until the mix is similar in consistency to mashed potatoes. Let sit overnight.

2. The next morning, stir a little coffee or tea into the paste until the consistency is lump-free and a bit softer than toothpaste. Cover and let sit until evening.

3. Test paste consistency by making patterns with a toothpick or cone on a paper towel. If too thick, add a little coffee. If too thin, add a little henna powder.

Add-Ins to Basic Recipe

Add-ins are thought to affect the vibrancy of henna's color and, sometimes, the texture of the design. You may want to choose one or two of these ingredients each time you prepare a basic henna paste and then decide which works best for you.

Lemon juice. Add ½ teaspoon (2.5 ml) freshly squeezed lemon juice to the initial mixture to brighten the color and extend the life of the design.

Dried-lime water. Lime acidity is thought to darken henna dye. Boil *dried* lime slices in water until water turns red. Reduce to half and add 3 black-tea bags. Reduce to one-fourth; cool. Add to henna paste a teaspoon (5 ml) at a time and let the mixture sit overnight.

Espresso. Brew espresso, cool it to room temperature, and add a teaspoon (5 ml) at a time to your henna paste. Use this in place of water in your henna recipe to intensify the stain.

Brewed black tea. Add tea leaves or bags to boiled distilled water; steep, covered, for 6 to 8 hours. Strain. Use this in place of water in your henna recipe for a deeper henna color.

Kattha, catechu (Acacia catechu). This powerful astringent and antiseptic, available in most Indian grocery stores, contains a red pigment. Boil a 1-inch (25 mm) piece of catechu in 1 cup (260 ml) of water; cool. Add to henna powder mixture.

Okra. The "milk" of okra adds a sticky texture to the paste — helpful when you plan to apply henna with a stick or toothpick. Soak 2 sliced okras in ½ cup (130 ml) boiled distilled water until it looks milky. Add to mixture one teaspoon (5 ml) at a time.

Fixing Mistakes

What happens if you smudge outside the lines? Did you drip paste somewhere you *didn't* want to decorate? Don't panic; there is a way to fix those mistakes. Here are a few tools to keep on hand for the inevitable slip-ups:

- Cotton swabs or tongue depressors
- Orange stick
- Rubbing alcohol

If you make a mistake, remove it immediately with a cotton swab, orange stick, or tongue depressor dipped in rubbing alcohol. Tongue depressors are available quite inexpensively from some pharmacies and medical supply stores.

Application Tools

A variety of fine-tipped henna applicators has been used over the centuries. Usually the tool was close at hand. Here are some examples:

- Fingers
- Thin twig, fishbone, or feather
- Flat-edged toothpick or matchstick
- Kohl stick
- *Mishwak* pick (from North Africa, this resembles a twig)
- Porcupine quill
- Plastic cone or plastic bag with a small hole
- Oral syringes (these have no needles)
- Small, disposable pastry piping tube
- Henna-dispensing tube or pen
- Jacquard bottle with a metal tip
- First-aid tape (used as a stencil)
- Vinyl or paper templates or stencils (self-adhesive type)

Applying Body Art

Different cultures and artists have their own unique henna application techniques. Experiment with different tools and methods to determine which are best for you.

MAKING THE HENNA CONE

Preparing the henna cone is an acquired skill that will become easier with practice. If you are planning a henna party, make up a dozen cones ahead of time and have them ready.

To make a henna cone, you will need:

- ❧ Quart-sized plastic zipper freezer bags, heavy-duty plastic freezer bags, or plastic from super heavy painter's drop cloths
- ❧ Long-bladed scissors
- ❧ Transparent adhesive tape
- ❧ Straight pins

Follow these steps for cutting and folding the cone:

1. Cut off the reclosable top of the freezer bag with scissors. Cut along the side and bottom seams to separate the plastic into two separate sheets. For other plastics, a comfortable cone size can be from 4 inches by 5 inches (10cm by 12.5 cm) to 4 inches by 7 inches (10 cm by 17.5 cm).

2. Fold the sheets in half. Holding the open edges with your thumb and index finger, cut across the closed edge. You now have four plastic sheets.

3. Holding the two sheets lengthwise, place your middle finger on the corner of the top one. Bring the opposite diagonal corner to meet the corner you are holding. Wrap the plastic over and over around your middle finger to create a cone.

3

4. Adapt the size of the tip opening and width of the cone by moving your middle finger inside the plastic sheets. The tip should be the tiny diameter of a straight pin.

5. Have several pieces of 1.5-inch (4 cm) precut tape ready. Carefully tape down the final plastic corner near the tip. Run at least one strip of tape vertically up the entire open seam. Tape as needed to seal the open edges, but do not tape the ends shut. Your cone will be about 6 inches (15 cm) long and have an opening that allows just a 2-finger space at the top.

4 5

6. Using a small teaspoon, fill the henna cone two-thirds full. With the top still open, shake the cone rapidly up and down until the henna mixture moves down to within ¼ inch (6 mm) of the cone tip. Wipe off excess henna near the top of the cone. Alternatively, you may place a heaping tablespoon (15-plus ml) of henna paste in the middle of the plastic sheets before you form them into a cone.

6

Fold down the wide end of the cone and use your thumbs and index fingers to squeeze the henna into the tip. Twist the wide end and secure it with a rubber band, or fold it down and secure with tape. Tape shut any other loose edges. If the tip of the cone is too small and paste is clogging the hole, use scissors to enlarge the opening, or poke a straight pin into the opening to loosen the clog.

Applying the Design

In the beginning, you'll want to use a larger hole in the cone tip. Have a paper towel handy to clear the tip of the cone from time to time. Remember, the color and design will hold better if the paste is allowed to remain on the skin for at least 1 to 3 hours.

1. Hold the cone between your thumb and index finger about ¼ inch (6 mm) from its tip. Touch the tip of the cone to the skin. Then lift up to release the henna paste. Trace the outline of the design on the skin, then fill in the details one section at a time. Lefties (that's me) should begin at the right side of the design and work toward the left.

2. As you are working the pattern, keep it moist so that it doesn't peel away. Use a cotton swab or square to gently apply a lemon-sugar solution — 3 teaspoons (15 ml) lemon juice mixed with 1 teaspoon (5 g) sugar — to the design. If you can, moisten the henna design every ½ hour for 3 hours.

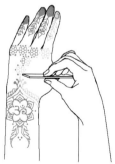

3. When you are ready to remove the paste, apply any oil — eucalyptus, mustard, avocado, sesame, olive, almond — generously over the design. Then use the flat edge of a butter knife, a credit card, or your fingernails to scrape off the hardened excess.

4. Avoid washing the area of the henna design for several hours. After the paste has been removed, smear the area with oil again. Each day, apply body oil to the design; it will help the drawing last longer. Those with darker skin tones might want to reapply the design on the following day for a longer lasting pattern.

Making Your Own Henna Transfer

Catherine Cartwright-Jones recommends photocopying a design that has been enlarged two times and then tracing over the paper outline with henna.

Let the henna get nearly dry to prevent smearing. Trim around the edge of the pattern. Put the paper, henna-side down, on the part of the body where you want the design; secure it with paper first aid tape.

Wrap with toilet paper, and cover this layer with plastic wrap. Leave the wrapping on overnight. The henna will rehydrate with your night's slight perspiration. In the morning, the henna imprint will remain in perfect detail, and you can fill in the outline as you wish.

Hints for Lasting Designs

You will get darker design color if you prepare the henna paste the night before you plan to create body art. Once the design is applied, a low-heat source, such as the low speed of a hair dryer, will dry it more quickly and help the design set better. If you feel cool during the application of henna, warm your body from the inside with a nice cup of steaming ginger tea.

The vapor from whole cloves boiled in water also facilitates setting. Or try wrapping the design with toilet tissue (1), securing it with adhesive tape (2), and covering all with plastic wrap overnight (3). Avoid washing the area for 24 hours.

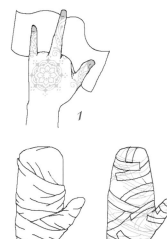

Don't use an exfoliating moisturizer that contains alpha-hydroxy acids over henna designs. (Unless you want to shed the image! If so, use suntan lotion on the area and scrub with a washcloth.) Almost all designs will have faded or disappeared in about three weeks. We are always naturally shedding our skin and growing anew. If you love the image, re-henna over the area.

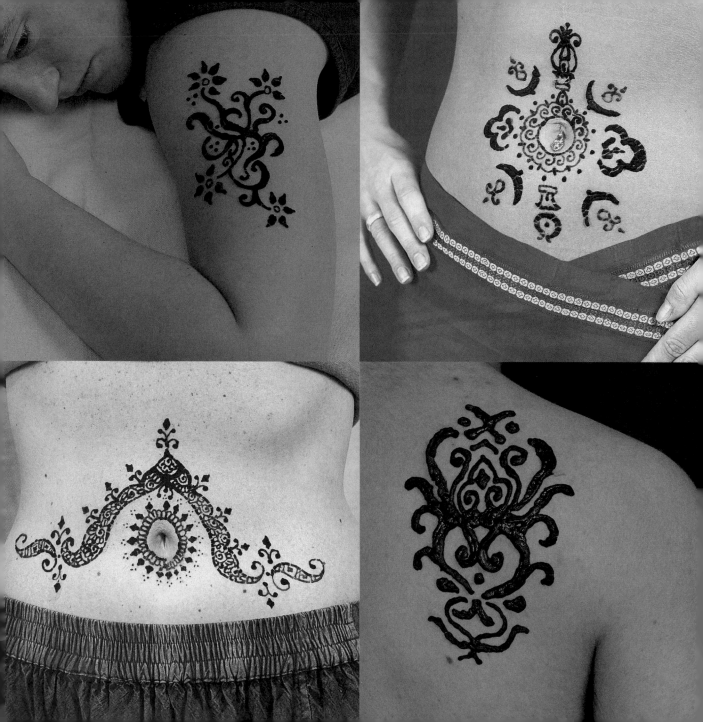

SpOt And BELLy-BuTTOn DEsIgns

Spot designs can be placed anywhere on the body. Because henna responds to warmth, the areas that have the best circulaton and are relatively "hair-free" will be the most successful.

Bellies are a challenge because our clothes' basic movements, such as in bending and sitting, impact the integrity of the pattern. Note that half circle designs will be less prone to smudges from belt buckles and underwear.

When painting on a belly-button design, you can choose between lying flat either on a blanket on the floor or bed or standing. Different bellies require different positions, and will offer varying results.

Ardagh Chalice

1 2 3 4 5

The Ardagh Chalice is a relic of Irish art from the 8th century. It is considered a most sacred vessel to those of the Christian faith. The continuous, interlacing knotwork derived from Celtic art is symbolic of continuity, representing God as an unbroken line around and through everything else.

Note: Colored lines show additions to be made in each step.

◁ **Clockwise from top left:** A spot design of petals and vines adorns a shoulder; an adhesive ornament highlights this contemporary style belly-button design; large, bold spot designs work well on darker skin; this half-circle design just above the belt line is less likely to smudge from contact with clothing.

Since the Yuan Dynasty, the lotus has been honored in China because it is a flower that grows from difficult surroundings and yet retains its purity. The lotus symbolizes compassion and knowledge developed from a cycle of rebirth or reincarnation. Use this pattern as a spot or belly button design.

Lotus Tapestry Design

Wear this navel or breast design when you want to speak your love. In Turkey, the carnation is viewed as a token of commitment and luck, and their colors symbolize admiration and fascination (red), impassioned love (white), and the love of a mother or woman (pink).

Carnation Design

Pakistani Peacock

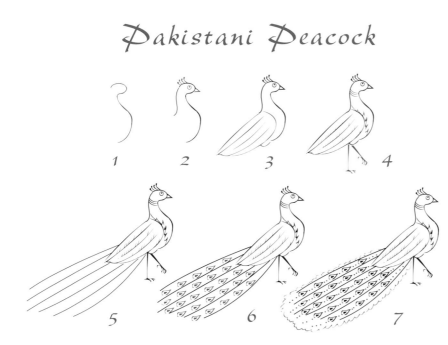

1 2 3 4

5 6 7

Peacocks are the most magnificent birds. Their beauty and elegance makes them both sacred and the national bird of India. In art, the peacock implies longing for a departed lover. The peacock design provides a beautiful memory and a needed companion.

Yin/Yang and 8 Trigrams

1 2 3 4

Yin and Yang are two elemental, opposing forces that balance the universe and cause continuous transformations. The trigrams reflect the laws of the universe. Choose this pattern as a symbol of balance in your life.

Kokopelli is a hump-backed flute player, a 3,000-year-old symbol of the Zuñi and Hopi tribes of the Southwest United States. He is a loving spirit symbolizing fertility of the earth and humanity. Wear this design if you are a generous, giving person.

This is a central Asian illustration that symbolizes life itself, as well as growth and good fortune. If you are influenced by the cycles of the sun and the moon, show your colors and wear these wonderful images!

Kokopelli

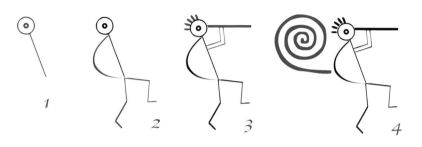

Sun and Moon Design

Pakistani Circular Flower

1

2

3

4

5

This flower reflects a *mandala,* the Sanskrit name for circle or circular design. The mandala is a sacred image that represents the universe. This design will appeal to your nature if you are the type that likes to create "ripples."

Mehandi Paisley

1

2

3

4

5

6

The paisley is an Indian pattern taken from nature — whether it be mango leaves, flames, or rain drops. It is a symbol of abundance. Wear this design if you prefer lacy, delicate images.

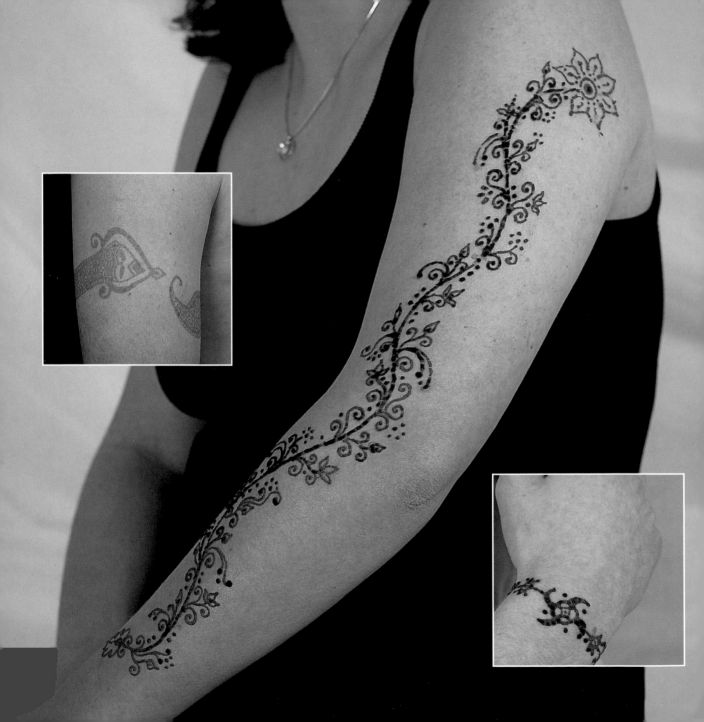

ARM AND
...WRIST DESIGNS

Bracelets offer special challenges. Try to begin the design in the center of the wristband, and extend to either side. Traveling toward the thumb might feel more comfortable than toward the pinkie. If you are right-handed, it will be easier to draw from left to right; lefties will most likely feel comfortable drawing designs from right to left.

Armband designs pose a particular challenge because they completely encircle the arm. To finish the underside pattern on a henna armband, have the subject rest his or her hand and forearm over the shoulder of the henna artist, on top of a chair, or on a wall. It is quite difficult to paint a complete armband on yourself; this is the perfect opportunity to enlist the help of friends.

To help keep an armband design straight, you may find it helpful to tie two parallel strings around the arm using light packing twine. Draw the pattern outline between these borders, then carefully remove the string and fill in the design.

Be creative with henna patterns and the language of body art. Extend designs vertically down the upper arm, or up the forearm from wrist to elbow. Celebrate the physical and social body, and communicate with the outside world. There is magic in this herb!

◁ The arm is an ideal place for a long, meandering pattern. Or, try wrapping a design around your upper arm or wrist (see insets). The left inset shows a finished design.

Henna and the Spiritual World

Over the millennia, henna body decoration has been used at times of vulnerability and transition, where there is a concern for the crossing of boundaries. Some examples of this transition include birth, maturity, marriage, travel, and death. The mark of henna is an auspicious guardian symbol during these rites of passage.

In Arab countries, when one sees a person sporting a beautiful henna design, the custom is to say, "b-sahaa l-hinna" or "wear this henna in good health and good fortune." It is a worthy saying in any language!

The acacia, a flat-topped umbrella tree, is one of the only trees hardy enough to survive in the harsh deserts of Arabia and southern Africa. An armband that reproduces the leaves of the acacia (pronounced *uh-KAY-sha*) suggests persistence, adaptiveness, and long life.

Note: Colored lines show additions to be made in each step.

Acacia Band

1

2

3

3a 3b 3c

Orange Blossom Band

1

2

3a 3b

3

4

5

In many countries, orange blossoms are the traditional adornment of brides. The white flowers are a sign of purity, chastity, and generosity.

This aboriginal design is thousands of years old and borrowed from petroglyph carvings found in central Australia. The snake, Yarapi, is held in respect and awe by many cultures as a symbol of water or rain, fertility, longevity, wisdom, and healing.

A native of Europe and northern Asia and grown in eastern North America, Scotch Pine has many practical uses. Because this tree is an evergreen and retains its needles even in the coldest weather it is a symbol of long life. The tree's needles occur in pairs and personify the strength of faithful companionship.

Snake Spirit Band

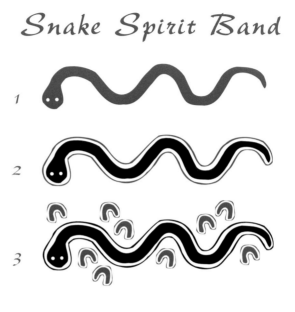

Scotch Pine Band

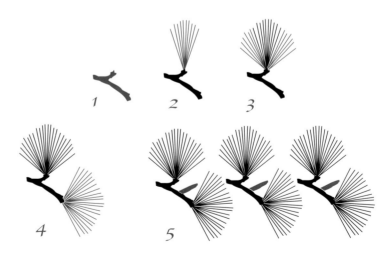

Pakistani Block Motif Band

This Pakistani design celebrates awareness of the environment — mountains, waves, peaks and valleys. Someone who wears this pattern is attuned to nature and the earth.

Tunisian Band

The geometric patterns of this armband may represent the play of light on the mountains and the desert sands as the sun moves across the sky. The person who wears this design is resilient and able to withstand the challenges of life.

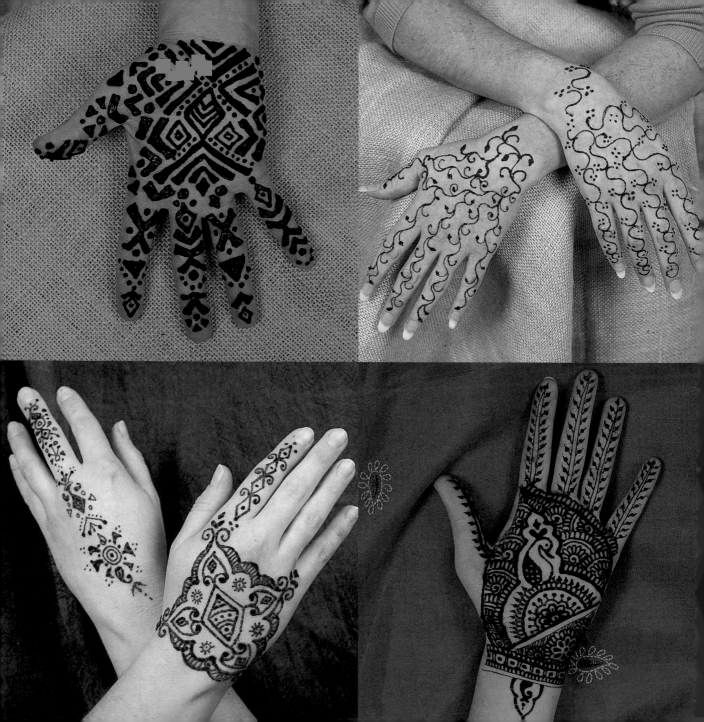

HAND DESIGNS

Having designs painted on your hands suggests that you are taking time for yourself. It is a wonderfully relaxing and refreshing experience, and can be comforting to have someone hold your hand while painting. Afterward, though, you must avoid daily chores while the design sets and the color deepens.

Paint henna on both sides of your hands and extend the patterns to the wrist or arm. Continuing the design from the base of the palm to the inner wrist will involve a change in henna color because the textures of the skin in these two areas are very different. Plan the patterns to accommodate this alteration in tone. Before you begin, be sure the skin is clean, dry, and free from any oil or lotion. Warm, freshly washed hands take henna very well.

Designs may simulate delicate lace gloves, natural objects, and geometric forms. Many of these patterns have cultural significance. For instance, in Indian culture, *mehndi* flowers indicate vitality. Waves or water are a symbol of abundance. Checkerboards say that you are in a playful mood, while parrots or peacocks speak of a loving nature. Eyes offer the power to protect, and grapevines symbolize the spirit of dedication.

The hands are prime for henna beauty. These appendages grasp the planet and communicate with its inhabitants. Since the skin is coarser and more porous here than elsewhere on the body and is mostly hair-free, the henna color will appear more vivid on the hands.

Henna Stencils and Transfers

The shapes of our various body parts create challenges to design application and care. If you're having difficulty, temporary design outline transfers are available, and offer a thin outline or road map you can color in with your henna. The transfers are a henna-colored ink made from organically based iron pigments, and are classified by the FDA as safe. You can also try henna stencils, which are available in a variety of patterns. (See Resources for more information.)

◁ **Clockwise from top left:** A North African palm design utilizes widely-spaced, geometric shapes; vines and scrolls are typical of an Arabian design; a peacock forms the focal point of this complex Indian pattern; two different modern designs make this pair of hands distinct.

This henna pattern for the palm of the hand is derived from writings and sculptures found in ancient Egyptian tombs. Anubis, depicted with a human body and a jackal's head, was thought to be both a judge of truth and a guardian or protector. Anubis decided the path the soul would take after death. Someone with an interest in the exotic past will enjoy this design.

Note: Brown lines show additions to be made in each step.

Anubis Palm Design

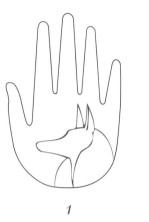

1

2

3

4

Magic Amulet Palm Design

1

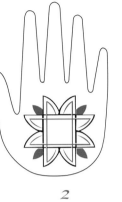

2

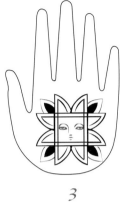

3

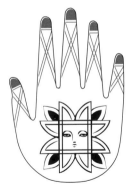

4

5

This pattern comes from an Ethiopian amulet showing a divine, all-seeing face. The protective charm was called upon to invoke the magic and power of the wise King Solomon of biblical times. Try this design if you want to add some magic to your life.

This pattern for the palm of the hand is adapted from a traditional zigzag, spiral tattoo of New Zealand's First Nation, the Maoris. It might tell of the journey these brave people took across the Pacific Ocean to reach their new land.
Try this pattern if you have adventure and travel in your future.

New Zealand Ancestor Tracing Palm Design

1 2

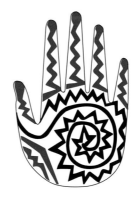

3

Mehandi Floral Design

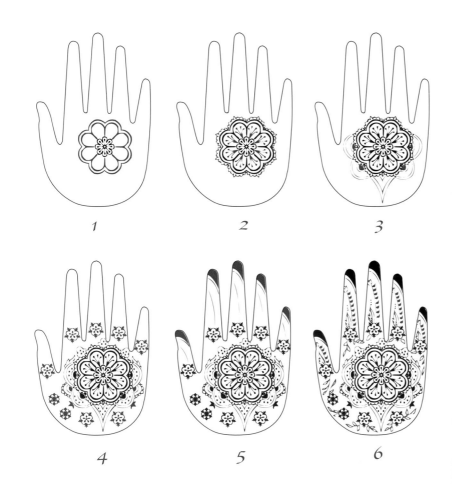

1 2 3

4 5 6

The lotus flower is especially revered in Asia and India, and several cultures enjoy the flower and its fruit as a culinary delight. A "lotus eater" is a day-dreamer who nurtures an ideal life of gentle indifference to the busy world. If this is the life you crave, you might wish to use this design on your palms as a symbol of taking yourself to another place.

There is a belief among many peoples that a harmful spirit, or "evil eye," exists, and that one's self or property can be influenced simply by being observed by the spirit. Amulets or protective ornaments are worn or applied to the walls of homes to ward off these malevolent forces. This design is for the back of the hand.

Moroccan Amulet Design

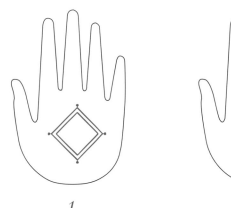

1

2

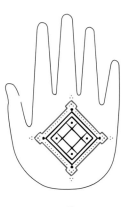

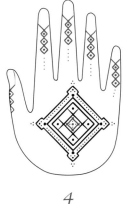

3

4

Mehandi Design

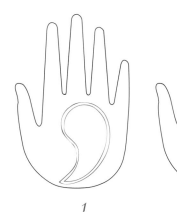

1

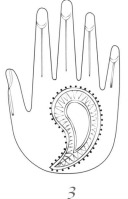

2

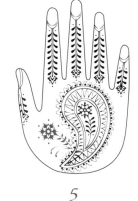

3

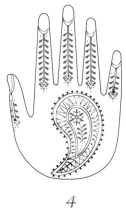

4

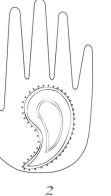

5

Paisleys are curved, colorful, abstract shapes borrowed from nature. In India, this ornament is often linked to the mango, one of the most esteemed tropical fruits. Buddha was given a grove of mango trees as a place of shade for meditation. One Indian poet described the mango as a "sealed jar of paradisical honey." Choose this design for the back of your hand to denote beauty.

Followers of Islam
are advised not to
reproduce human forms
in art. Therefore, Islamic
designs focus on the
beauty of nature. Vines
have been venerated from
biblical times and are
symbols of fruitfulness
and productivity. Paint
vines on the back of your
hand to share your love
of nature.

Vines of Arabia's Frankincense Trail

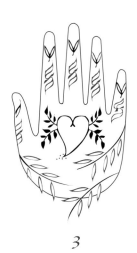

1

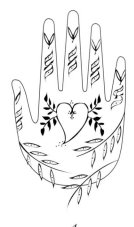

2

3

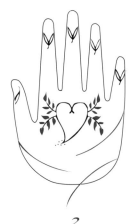

4

Finger Designs

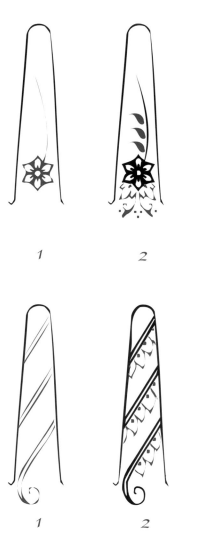

1 2 3 4

1 2 3 4

Enhance the symbols you choose for your hands by embellishing your fingers. What message do you want to send to interested observers? Remember to start henna finger designs with the middle finger and work up from the palm toward the tip. On the back of the hands, the knuckles are apt to take henna dye more darkly than on the palm side of the hand. Plan your patterns accordingly. Also, be aware that if you stain the fingernails with henna, it will not wear off. Instead, you will have to wait for the nails to grow out.

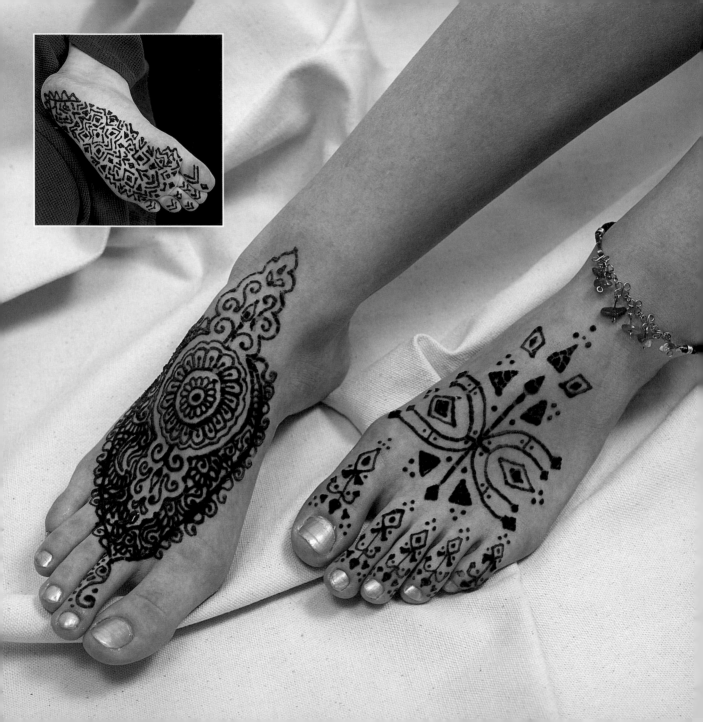

...FOOT, LEG, AND ANKLE DESIGNS

Painting the feet — other than a rare pedicure — is an unusual occurrence in Western culture, but it is a delicious experience. The challenges of painting this area include: ticklish feet and not being able to walk while the henna paste is still drying.

When making anklets, paint three-fourths of the way around the ankle, then break and begin at the point of origin to meet the encircling pattern where you left off. Pull on a large rubber band or tie a piece of string around the ankle for use as a guide.

Yemenite Bridal Design

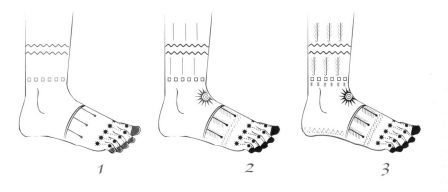

1　　　*2*　　　*3*

This simple pattern represents a wish for abundance, for sunshine and water to bring forth grain. Symbolically, the easy, delightful Yemenite wedding pattern suggests fertility and bounty.

Note: Colored lines show additions to be made in each step.

◁ Before the dried paste is removed, these gorgeous foot designs appear black. They will be a rich reddish-brown when scraped clean. Painting the bottom of the foot (inset) might tickle, but it's a fun experience to try!

In hot desert countries, henna is often applied on the sole of the foot to protect the skin from ground heat. In a traditional "gassah" foot design there is a curve upward at the arch of the foot and an undyed space beneath the big toe. This pattern is adapted from one used in the United Arab Emirates.

Desert Pattern

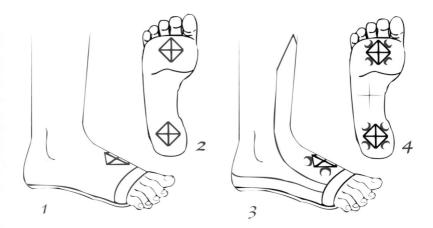

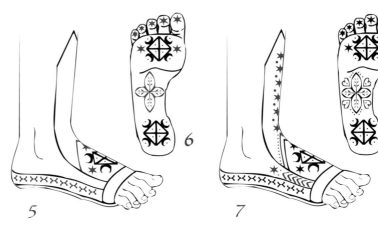

Taped Geometric Design

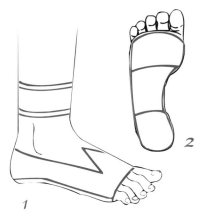

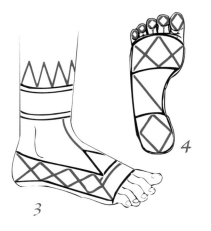

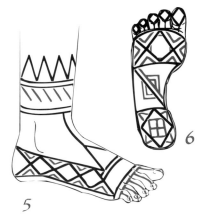

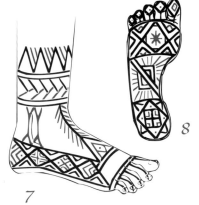

This pattern, adapted from techniques used in Mali, is usually used on the top of the feet. An unusual way of applying henna, this technique requires strips of first-aid adhesive tape to create a stencil pattern of squares, rectangles, and triangles. It is a perfectionist's dream to decorate the feet this way, and it yields unique results. In traditional Malinese designs, the bottom of the foot is a solid color.

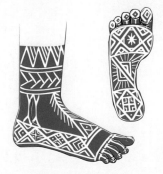

Design after henna and tape are removed

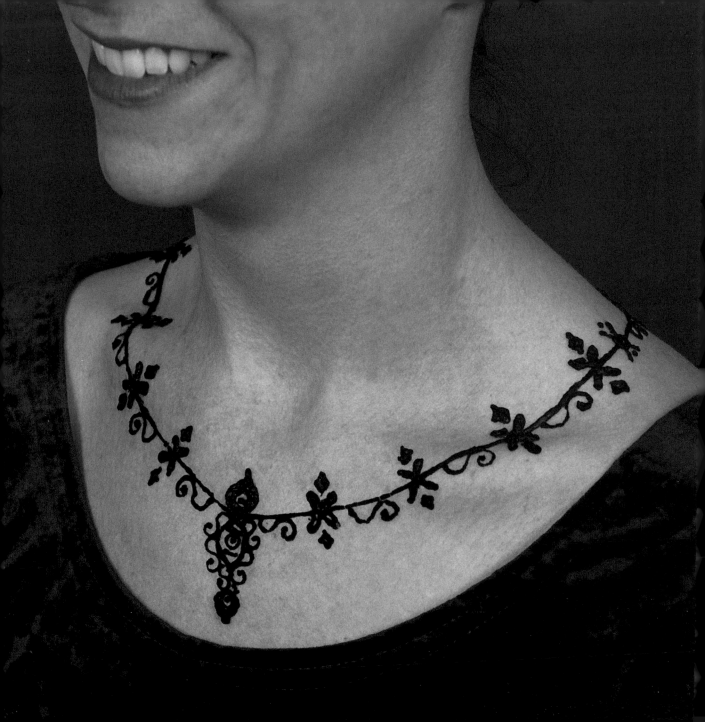

CHEST, BACK, AND NECK DESIGNS

Chest and neck designs are not traditionally painted in henna. The skin is thinner in these areas and not as porous so the henna stain will be lighter and endure for a shorter period of time. Nevertheless, it is fun to experiment in these areas with designs that might resemble jewelry. The neck is a formidable challenge because of the difficulty of the subject remaining perfectly still during the application and drying period.

Nothing is more attractive than adopting nature's patterns as an adornment for your neck or back. Vines suggest someone who has high spirits and is productive in what he or she does.

Note: Colored lines show additions to be made in each step.

Vine and Leaves Necklace

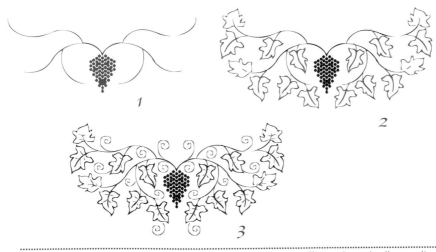

1

2

3

◁ The neck is a challenging place to apply a henna design, but the effort produces dazzling results.

*I*f you are the type that prefers to follow the path of the sun, then speak the language of flowers with this natural neckpiece design.

Sunflower Necklace

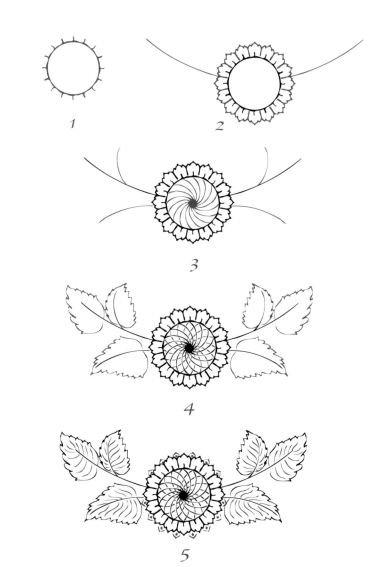

1

2

3

4

5

Dragonfly
Necklace / Backpiece

The dragonfly is a graceful, long-bodied, beneficial insect most often seen flying along the borders of lakes and streams. It has resided on this earth for 320 million years! Because of its intricate wing structure and needlelike shape, this species is a favorite in art designs.

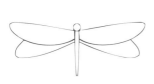

1

2

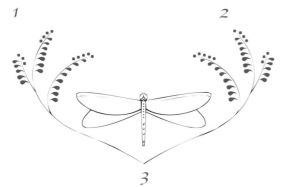

3

4

HENNA WEDDING TRADITIONS

Write my beloved's name with henna hands –
now go quickly and bring the groom.

— Indian wedding song

Marriage is a transition from single spirit to coupled life. Many cultures believe that the twosome is vulnerable to evil spirits during this time. To safeguard the pair, a pre-wedding henna ceremony is customary in Islamic and Hindu countries, from Morocco and Mauritania in the West to Saudi Arabia, Pakistan, India, and Southeast Asia in the East.

YEMENITE TRADITION

According to Jewish Yemenite tradition, henna is a symbol of happiness and protection. On the Wednesday before the wedding, the hands and feet of the groom are colored simply. The henna coloring of the bride is completed in four phases over the four days prior to the wedding. The fingertips, fingernails, backs of the hands and feet, and face are colored.

The cheeks and forehead of the bride are colored in a pattern. The coloring is accompanied by dancing and songs that speak of the days of childhood and nostalgia and prepare her for the separation from home. The mother of the bride or someone else of her choice puts a

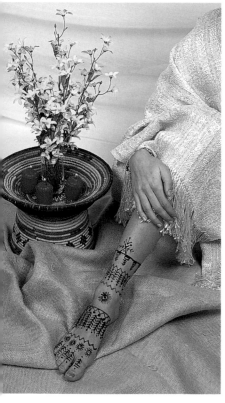

△ The painting of the feet is one of the four phases of coloring in a Yememite bridal design.

small amount of henna paste on the palms of the bride and groom as part of the ceremony.

North African and Arabian Tradition

In North Africa and the Arabian Peninsula, the traditional night of henna is a rite of passage that purifies, strengthens, and protects the bride. The henna artist is usually a relative.

After a ritual bath, the bride is painted. She will usually draw the idea of the pattern she desires, and the henna artist will elaborate on it. The occasion includes lighting candles, loud music, dancing, singing, and feasting.

The groom may have his own henna ceremony. The best man applies the henna to the palms of the bridegroom's hands. Then the best man will apply henna to his own pinkie while he sings.

Afghanistani Tradition

In northern Afghanistan, the marriage celebrations are organized into a period of 2 successive nights and a following day. All celebrations are planned, conducted, and attended by women only. During the first night's celebration, or *shao-i khinna* (the night of the henna), the bride's hands are dyed with henna paste.

At the night of the henna, female relatives of the groom go to a party at the bride's mother's home. Seven of the groom's relatives dab her right hand with henna. The bride's left hand is also dyed, and usually enough henna is brought to dye the guests' hands.

Indian and Pakistani Tradition

In India, a *mehndi* artist or *mehndi walle*, sometimes includes the initials or name of the groom within the bride's intricate henna

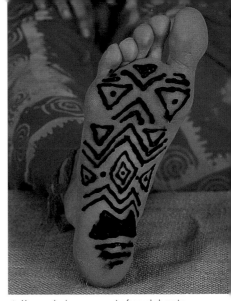
△ Henna designs are part of an elaborate North African prenuptial ceremony.

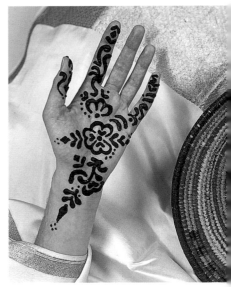
△ The typical Arabian bridal pattern includes flowers and vines.

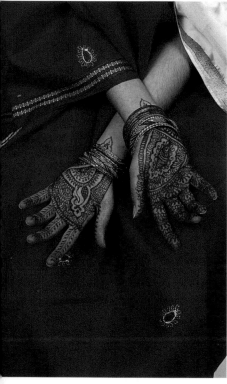

△ Intricate Indian wedding designs look similar to patterns found on fine lace.

patterns; the groom searches for these on the wedding night!

Mehndi is a mark of lasting love between a husband and a wife and one of the 16 adornments of a married woman. In India, red is considered an auspicious color; the deeper the color of *mehndi* on a woman's palms, the more she will be loved by her husband.

A bridegroom must praise the beauty of his bride's hands. Bridegrooms have their palms colored on their honeymoon day.

EGYPTIAN TRADITION

Egyptian brides also celebrate the *leylet el-henna*, or "night of the henna. The bride and her close friends go to the *hammam* (bathhouse) to purify their bodies.

At the following party, a large quantity of henna is made into a paste. The bride takes a lump of it in her hand, to which each guest adds a coin (usually gold). When the lump is stuck with many coins, she scrapes it off her hand.

More henna is applied to her hands and feet, which are then bound with pieces of linen until the next morning. The remainder of the henna is used by the guests.

ARMENIAN CHRISTIAN TRADITION

A Christian Armenian prenuptial custom is a henna party held the night before the wedding. The bride-to-be is seated in the middle of a room.

Each person dances around the bride with the decorated henna tray and gives her a kiss. Then, guests dip their pinkies into the henna paste. The bride's sisters or bridesmaids wrap each pinkie with plastic wrap and a ribbon. The henna dye is visible the next day in church to signify the family's support of the marriage.

GALLERY OF ADDITIONAL DESIGNS

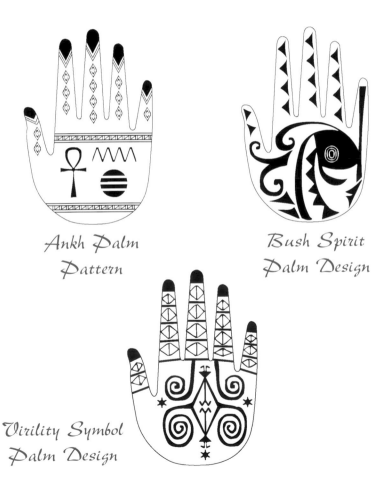

Ankh Palm Pattern

Bush Spirit Palm Design

Virility Symbol Palm Design

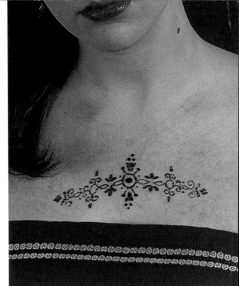

△ Even a small chest design can have a big impact.

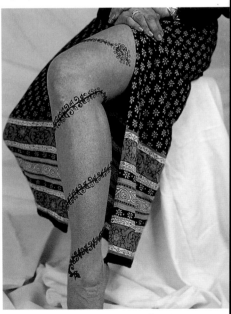

△ While tricky to create, this spiraling leg pattern makes an eye-catching decoration.

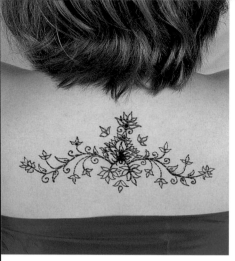

△ When applied just above the shoulder-blades, the traditional necklace becomes an intriguing backpiece.

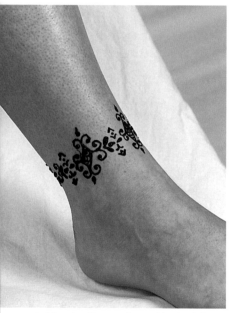

△ A band pattern can be used to simulate an anklet. Bands are also used around the wrist, upper arm, and thigh.

Divine Approval Band

French Tapestry Band

Anatolian Ram's Horn Band

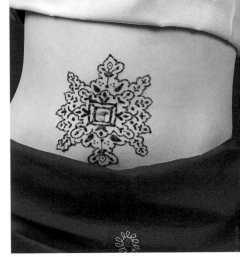

△ This sharp-edged lacy pattern provides counterpoint to the circular shape of the belly button.

Art Nouveau Spot Design

Crocodile Spirit Band

△ A masculine modern design borrowed from South American art adorns a shoulder.

Recommended Reading

BOOKS

Battesti, Marie. *Etude Botanique du Lawsonia Inermis L. These* (A Thesis for the Botanical Study of *Lawsonia Inermis*). Université de Montpellier, France: Firmin, Montane et Sicardi, 1910. (Botany, properties, and uses of henna; written in French.)

Bhanawat, Mahendra. *Menhadi Rang Rachi* (Folkloric Study of Colorful Myrtle). Udaipur, Rajasthan, India: Bhartiya Lok-kala Mandal Publishers, 1976. (Folklore, *menhadi* henna customs in the area around Udaipur, India.)

Bremness, Lesley. *Herbs.* Eyewitness Handbooks. New York: DK Publishing, Inc., 1994.

Dori, Zekharyah. *Ha-Pukh veha-kofer: ha-kuhul veha-hina* (Kohl and Henna). Jerusalem, Hamad Publishing, 1982. (Yemenite life and customs, including interesting henna patterns.)

Fabius, Carine. *Mehndi.* New York: Three Rivers Press, 1998. (Good, practical advice.)

Kanafani, Aida S. *Aesthetics and Ritual in the United Arab Emirates.* Beirut: American University of Beirut, 1983. (Personal adornment among Arabian women.)

Lane, Edward William. *An Account of the Manners and Customs of the Modern Egyptians 1833–1835.* The Hague and London: East-West Publications, 1836, 1895, reprinted 1978. (Egyptian life and henna customs.)

Lawson, John. *A New Voyage to Carolina,* edited by Hugh Talmage Lefler. Chapel Hill: The University of North Carolina Press, 1967. (An account of nature and Native American life in Carolina in the 1700s.)

Lyman, Henry M., M.D., Christian Fenger, M.D., H. Webster Jones, M.D., and W.T. Belfield, M.D. *The Practical Home Physician.* Albany, N.Y.: Ross Publishing House, 1888. (How-to henna hair dyeing.)

Marron, Aileen. *The Henna Body Art Book.* Boston: Journey Editions, 1998. (Nice photos of henna designs.)

Phoenix and Arabeth. *Henna (Mehndi) BodyArt Handbook.* Ukiah, Calif.: self-published, 1997. (Easy-to-read ethnographic and historical information.)

Queens Council on the Arts. *Wedding Song: Henna Art among Pakistani Women in New York City* (videorecording). New York: 1990. (A peek into henna wedding parties.)

Saksena, Jogendra. *Art of Rajasthan, Henna and Floor Decorations.* Delhi, India: Sundeep Prakashan, 1979. (Wonderful descriptions of the cultural uses of henna.)

Resources

HENNA AND HENNA SUPPLIES

Radico Export-Import
Post Box No-211
P.O. Sector-16A
Faridabad-121002 India
Fax 91-129-291988
e-mail: radico@del2.vsnl.net.in
Complete range of henna products

Crayola Multicultural Washable Markers
Binney & Smith Inc.
Easton, PA 18044-0431
(800) CRAYOLA
Nontoxic markers in a variety of skin colors such as beige, mahogany, sienna, and tawny

Herb's Daughter
PO Box 264
Centerville, MA 02632
Fax (617) 547-6909
e-mail: herblady@ma.ultranet.com
Henna perfume — the kind Cleopatra used

Milan Mehndi Design
Carpet Corner
1–3, Joshi Building
50, Mohamedali Road
opp. Noor Hospital
Mumbai 400003 India
Henna stencils

Pearl Paint and Supply
(800) 221-6845, #3
Half-ounce Jacquard bottles with .05, .07 centimeter tips

Rani Kone Henna Paste
Rani & Co.
PO Box No. 2531
Karachi 74600 Pakistan
Fax 0092-21-661-5142
Prepared henna paste in a tube

Sanford Sharpie Series 30000
Brown, nontoxic, fine-point permanent marker that mimics the look of a henna tattoo

Temptu Marketing Inc.
26 West 17th Street
New York, NY 10011
(212) 675-4000
Fax (212) 675-4075
Web site: www.temptu.com
e-mail: roy@temptu.com
Nontoxic, FDA-approved transfers

Castle Art and Import
1525 South Webster Avenue
Green Bay, WI 54301
(888) 829-8018 or (920) 430-8826
Fax (920) 430-1976
Website: www.castleart.com
Henna powder, stencils, cones, supplies

HENNA ARTISTS

Halima Abdul-Ghani "Henna Lady"
PO Box 5048
Hillside, NJ 07205
(908) 686-9528
e-mail: TheHennaLady@webtv.net
Sudanese-style designs

Artista, a full service Moroccan salon and spa
138 Fifth Avenue
New York, NY 10021
(212) 242-7979
Full-service salon and spa; trendy henna designs

Sheryl Baba
J. Michaels Salon
684 Main Street
Hyannis, MA 02601
(508) 771-3335
Creative designs, gentle friend

Anita Bhatnagar, diplomate in textile design, specialist in henna-*mehndi* body makeup
(203) 348-6240
e-mail:
anita_bhatnagar@hotmail.com
A talented artist and teacher in Stamford, Connecticut

The Body Archive
9 Ninth Avenue
New York, NY 10014
(212) 807-6441
e-mail: bodyny@aol.com
Artists' resource network and research center on body art, body decoration, and culture

Catherine Cartwright-Jones
(330) 688-1130
e-mail: info@mehandi.com
Web site: www.mehandi.com
Artist and illustrator specializing in body decoration with henna. Printed henna patterns available.

Henna Arts International
190 El Cerrito Plaza, #168
El Cerrito, CA 94530
e-mail: hennaarts@yahoo.com
Worldwide listing of henna artists

Mehndi Designs
State Museum of Jaipur, India
Exhibits and archive of historical mehndi art designs

The Mehndi Project
The Gates of Marrakesh
8 Prince Street
Soho, New York, NY 10012
(212) 969-8820
Source of henna artists

Sacred Body Art Emporium
365 Canal Street
New York, NY 10013
(212) 226-4286
Web site: www.sacredtattoo.com
Henna artists; great source of mehndi design books from India; body art gallery

Amrita Udeshi
Framingham, MA
(508) 875-8348
e-mail: vikuronln@aol.com
Beautiful designs, great personality, will provide prepared henna cones for your projects

HENNA ON THE INTERNET

The Henna Page (A Guide to Henna Body Decoration)
Web site: www.bioch.ox.ac.uk/~jr/henna/
How, why, what, who, where; bibliography; forum; links; guestbook

HENNA IN THE MOVIES

Kama Sutra
Trident Films, 1997
Directed by Mira Nair; set in 16th-century India

The Last Temptation of Christ
Universal Pictures, 1988
A Martin Scorsese film

Henna Hair Color, Shampoos, and Conditioners

Jason Natural Cosmetics
8468 Warner Drive
Culver City, CA 90232-2484
(310) 838-7543
Maker of Jason Natural Henna Hi-lights Shampoos; neutral henna with a sunscreen

Logona USA
554 East Riverside Drive
Asheville, NC 28801
(828) 252-1420
Natural hair products including henna. Small trial sizes of henna hair color are available to pretest strands for hair color

Lotus Brands
Box 325
Twin Lakes, WI 53181
(800) 643-4221 or
(414) 889-8561
Manufacturer of Light Mountain Natural Henna for gray hair, available in several shades

Nature's Gate Herbal Cosmetics
9200 Mason Avenue
Chatsworth, CA 91311
(818) 882-2951
Maker of Nature's Gate Rainwater Herbal Henna Shampoo and Conditioner, pH-balanced products of neutral henna and other herbs in a coconut oil base for all hair colors

Rainbow Henna
Rainbow Research Corp.
170 Wilbur Place
Bohemia, NY 11716
(800) 722-9595 or (516) 589-5563
Fax (516) 589-4687
e-mail: info@rainbowresearch.com
Web site: www.rainbowresearch.com
Thirteen shades of organic henna hair colors, including neutral; no animal testing, chemicals, coal tar dyes, peroxide, or ammonia; also creators of henna shampoo, conditioner, and thermo heat cap

SBE Seed Catalog
3421 Bream St.
Gautier, MS 39553
(800) 336-2064, 01-601-497-6544
Web site: www.seedman.com
Anise seeds and more, including medicinal plants

Spectrum Naturals, Inc.
133 Copeland Street
Petaluma, CA 94952
(707) 778-8900
U.S. maker of coconut oil containing no preservatives or additives — a good hair conditioner after applying henna

Other Storey Titles You Will Enjoy

The Essential Oils Book, by Colleen K. Dodt. Learn how to use essential oils to make personal blends for both body and mental well-being. 160 pages. Paperback. ISBN 0-88266-913-3.

The Herbal Body Book, by Stephanie Tourles. Using an all-natural approach, this comprehensive guide offers recipes and advice for healthier hair, skin, and nails. 128 pages. Paperback. ISBN 0-88266-880-3.

The Herbal Home Remedy Book, by Joyce A. Wardwell. Readers will discover how to use 25 common herbs to make simple herbal remedies. North American legends and folklore are spread throughout the book. 176 pages. Paperback. ISBN 1-58017-016-1.

The Herbal Home Spa, by Greta Breedlove. These easy-to-make recipes include facial steams, scrubs, masks, and lip balms; massage oils, baths, rubs, and wraps; hand, nail, and foot treatments; and shampoos, dyes, and conditioners. Relaxing bathing rituals and massage techniques are also included. 160 pages. Paperback. ISBN 1-58017-005-6.

Natural Foot Care, by Stephanie Tourles. From simple recipes for creams, lotions, and ointments to foot massage techniques, this book offers dozens of natural ways to care for feet. Includes a chapter for athletes. 192 pages. Paperback. ISBN 1-58017-054-4.

Natural Hand Care, by Norma Pasekoff Weinberg. Focusing on alternative and preventive therapies and treatments, this book offers dozens of easy-to-make recipes as well as cosmetic products, exercises, and hand massage techniques. 160 pages. Paperback. ISBN 1-58017-053-6.

These books and other Storey books are available at your bookstore, farm store, garden center, or directly from Storey Books, Schoolhouse Road, Pownal, Vermont 05261, or by calling 1-800-441-5700. Or visit our Web site at www.storey.com.